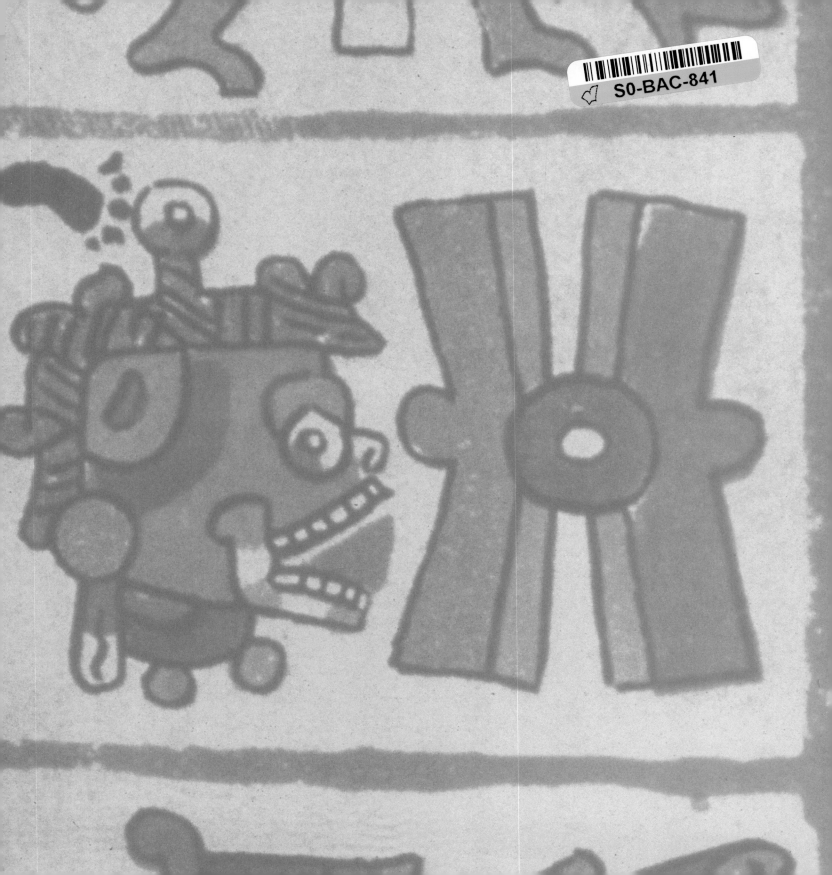

# THE ART OF **THE AZTECS**

LAUREL
GLEN

NIGEL CAWTHORNE

**Publishing Director:** Laura Bamford
**Executive Editor:** Mike Evans
**Editor:** Michelle Pickering
**Production Controller:** Joanna Walker
**Picture Research:** Wendy Gay

**Creative Director:** Keith Martin
**Design:** Vivek Bhatia

**North American Edition**
**Publisher:** Allen Orso
**Managing Editor:** JoAnn Padgett
**Project Editor:** Elizabeth McNulty

Published in the United States in 1999 by
**Laurel Glen Publishing**
**5880 Oberlin Drive, Suite 400**
**San Diego, CA  92121-4794**
**1-800 284-3580**

Copyright © 1999 Octopus Publishing Group Ltd

Cawthorne, Nigel.
    Art of the Aztecs / Nigel Cawthorne.
        p.    cm.
    Includes bibliographical references.
    ISBN 1-57145-639-2
    1. Aztec art.  2. Aztecs.  I. Title
F1219.76.A78C39  1999                98-49125
704.03'97452--dc21                        CIP

Printed and bound in China

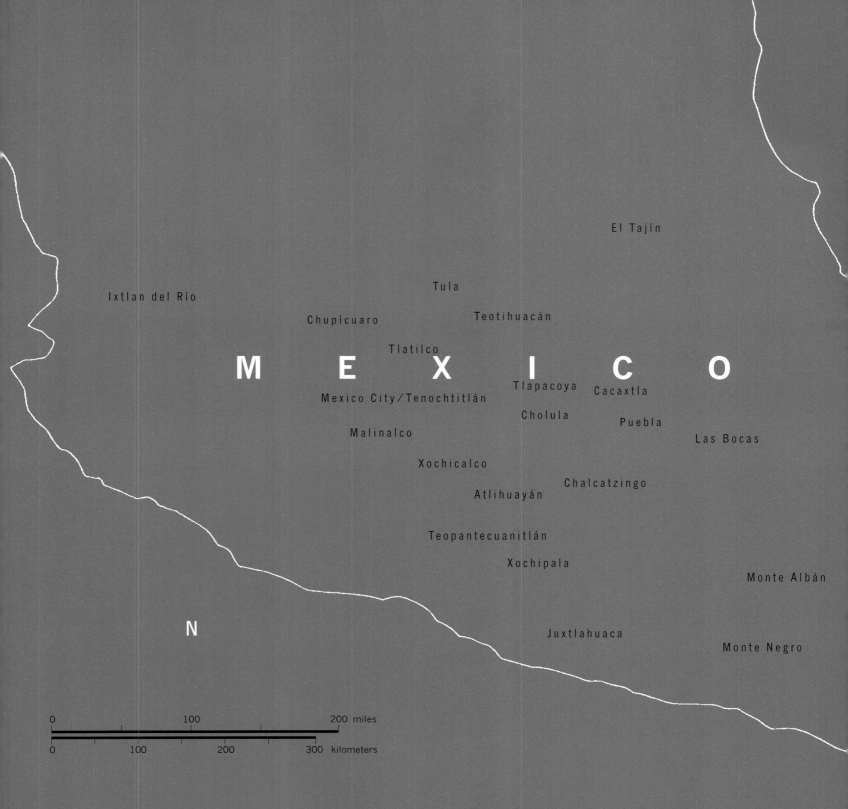

El Tajín

Tula

Ixtlan del Río

Chupícuaro

Teotihuacán

Tlatilco

**M E X I C O**

Tlapacoya　Cacaxtla

Mexico City／Tenochtitlán

Cholula

Puebla

Malinalco

Las Bocas

Xochicalco

Chalcatzingo

Atlihuayán

Teopantecuanitlán

Xochipala

Monte Albán

N

Juxtlahuaca

Monte Negro

| 0 | | 100 | | 200 miles |
|---|---|---|---|---|

| 0 | 100 | 200 | 300 | kilometers |
|---|---|---|---|---|

**P A C I F I C   O C E A N**

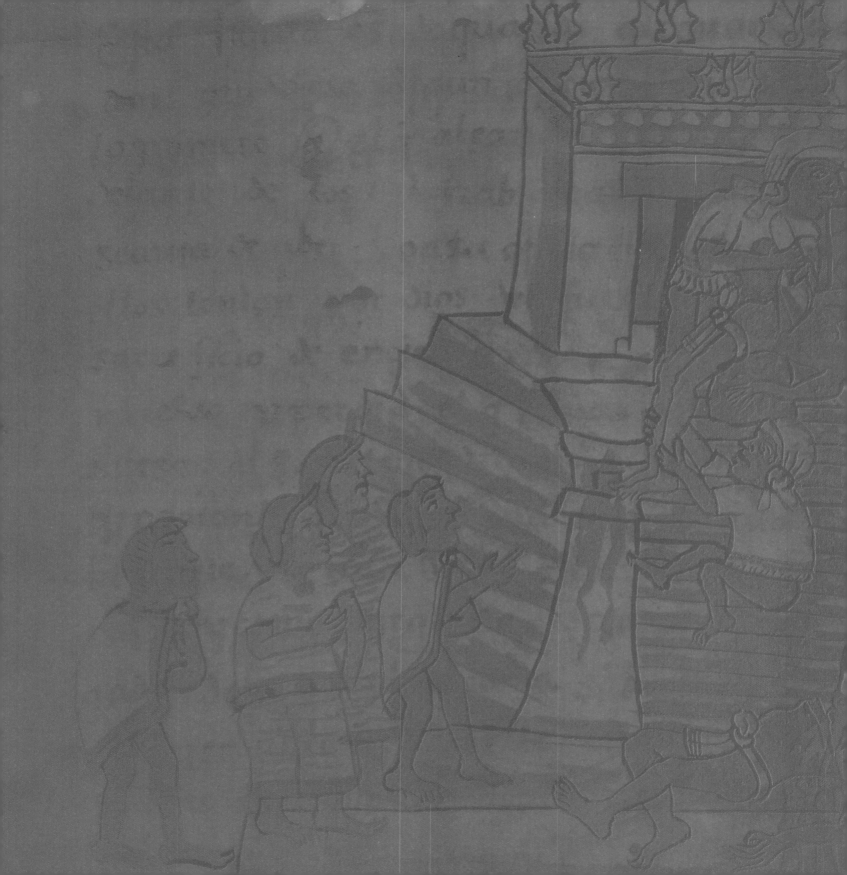

INTRODUCTION

The conventional view of the **A z t e c s** is that they were the most bloodthirsty people who ever existed. While it is true that they practiced human sacrifice and would sometimes dress themselves in the flayed skins of their victims, this is by no means the whole story. The Aztecs were the last of the four great civilizations–the **O l m e c**, **Teotihuacán**, **Mayan,** a n d **Aztlán**–that had flourished in Mexico since the first millennium B.C.

The Aztec civilization was a relatively young one at the time of its destruction at the hands of the Spanish nobleman **Hernando Cortés** in 1521. The Spaniards regarded the conquest of Mexico as a crusade. Battles against "the infidel" on home ground were fresh in Spanish minds. Granada, the last great stronghold of the Moors, had only been recaptured by the Spanish in 1492. Muslims and Jews were immediately expelled; those who remained were forcibly converted.

Cortés conquered the Aztec empire with just 500 men, 16 horses, and one canon. Almost as important was his mistress, a slave named Malinche, later baptized as **Doña Marina**. She spoke both Mayan and the Aztec language **Nahuatl** as well as Spanish and played a crucial role as Cortés's interpreter throughout the campaign.

The Aztecs had a glimpse of their fate when, between 1507 and 1510, strange ships were seen off the coast of Mexico. Then came a series of ill omens: a comet appeared in the sky, lightning struck a temple, the sound of women weeping was heard at night. In response, the Aztec ruler **Montezuma II** (also spelled Motecuhzoma) exe-cuted anyone who reported these portents of doom. It did no good.

Another fatal flaw in the Aztecs' defenses was their own legend. The Aztecs believed that the god **Quetzalcoatl**, the mythical ruler of the Toltecs, the Aztecs' precursors, had been exiled and would return in the year I Reed, according to the Aztec calendar. I Reed was 1519, the year the Spaniards arrived. Accordingly, Montezuma assumed that they were gods and that their ships were wooden temples.

He sent gold and magnificent costumes made of feathers to the "gods" in the hope that they would take the gifts and leave. Instead, Cortés seized the Aztec messengers and put them in chains. He gave a demonstration of his god-like powers by firing his canon, which made them faint. Cortés proceeded to establish himself at **Veracruz**, where he burned his ships so that his men could not flee back to Cuba. He then began his march on the Aztec capital of **Tenochtitlán.**

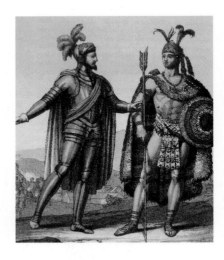

▶ **The Aztec god Quetzalcoatl**
Turquoise and shell mask, c.1500.

▲ **Cortés and Montezuma**
The Spanish invader and the Aztec ruler.

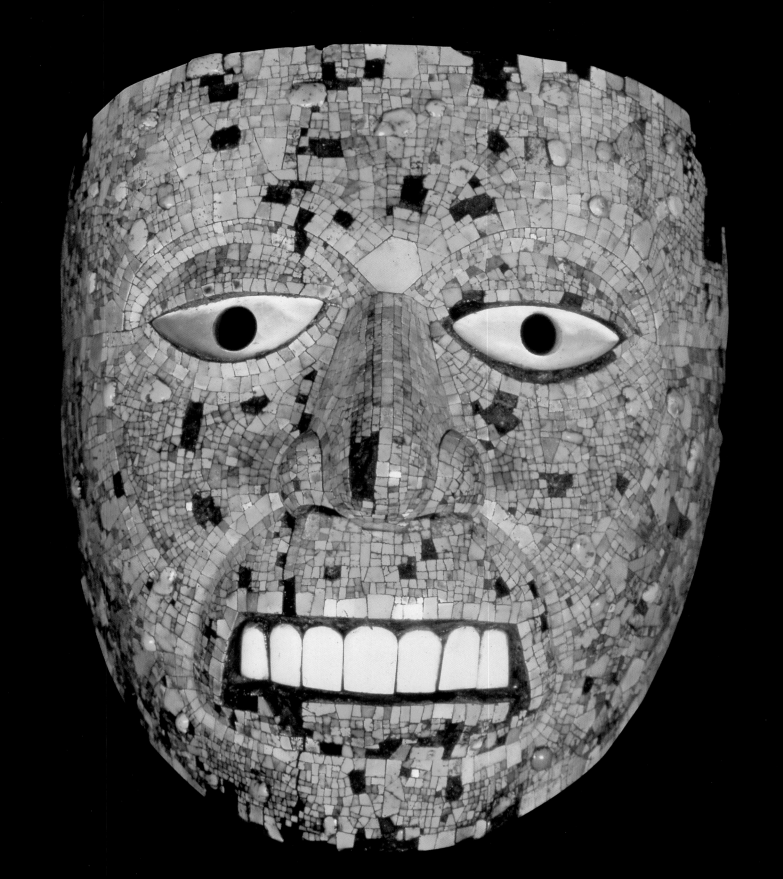

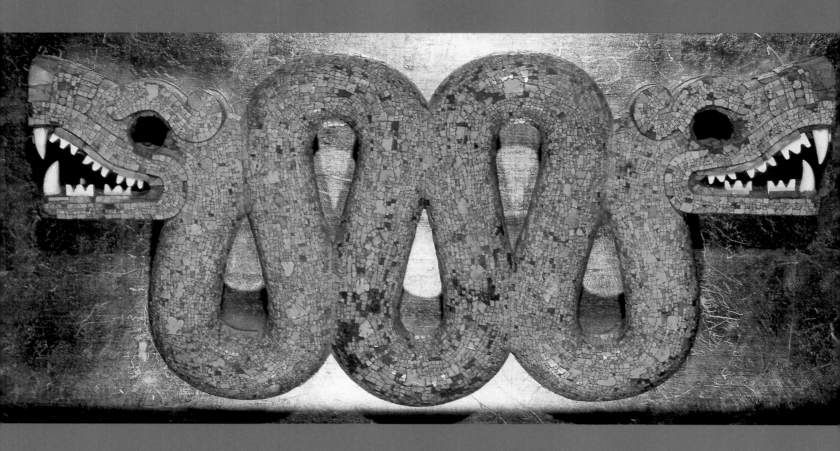

▲ **Turquoise pectoral ornament**
Part of the treasure given to Cortés by the Aztecs on his arrival in Mexico.

With armor, muskets, crossbows, swords, and horses, the Spanish had overwhelming military superiority. War for the peoples of pre-Columbian Mexico was largely a ceremonial affair. They wore elaborate costumes and were armed only with a small sword made out of obsidian–volcanic glass.

Their object was to capture as many of the enemy as possible to use as human sacrifices later. If a leader was killed or a temple captured, the loser capitulated immediately and talks began over the amount of tribute that should be paid. Cortés did not play by the rules, however. He simply slaughtered as many Aztecs as he could on the battlefield.

Montezuma's only possible defense was guile. He tried to capture Cortés in an ambush at **Cholula**, but Cortés discovered the plan and massacred the citizens of Cholula. He then destroyed the temple of Huitzilopochtli, the Aztec god of war, and set up an image of the Virgin Mary instead. It was a key psychological victory.

Cortés then established an alliance with the people of **Tlaxcala**, who had only recently been conquered by Montezuma. When they rebelled against their Aztec overlord, more of the subject peoples rallied to Cortés against the Aztecs.

To make matters worse, upon hearing what had happened at Cholula, other Aztec cities surrendered without a fight and Cortés marched on Tenochtitlán unopposed.

Montezuma had no choice but to greet the Spaniards graciously. He lodged Cortés in the palace of **Axayacatl**, Montezuma's father, which was packed with golden ornaments. These were quickly melted down by the Spaniards. Decorative stones and feathers were thrown away, and the gold was shipped back as bars directly to Charles V in Spain, bypassing Cortés's commander, the governor of Cuba, **Diego Velázquez**. Cortés also demanded that Montezuma swear allegiance to Charles V, although Montezuma would remain nominal ruler of the Aztecs while Cortés himself seized the reigns of power with the aim of becoming viceroy.

To reassert his authority, Velázquez sent a force of over 1,000 men under **Panfilo de Narváez** to bring Cortés to heel. Leaving a small force under the command of **Pedro de Alvardo** in Tenochtitlán, Cortés headed back to the coast where he defeated Narváez, whose troops then swelled Cortés's own ranks.

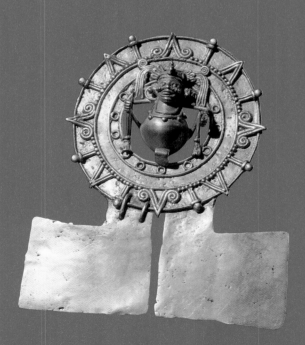

▼ **Golden sun pendant**
One of the few golden jewels not melted down by the Spanish.

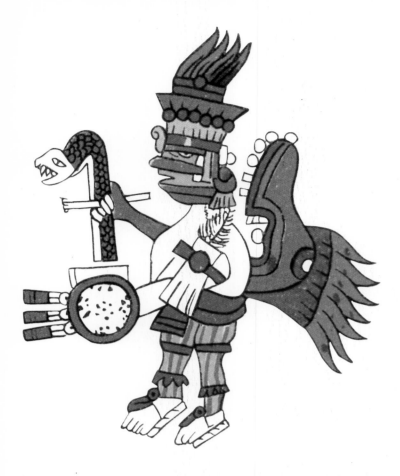

**▲ Huitzilopochtli, the god of war**
The Aztecs celebrated their god's festival with human sacrifice.

**► The city of Tenochtitlán**
Celebrations at the city's temples for the festival of the Aztec war god.

HUITZILO
POCHTLI

Meanwhile, back in Tenochtitlán, the Aztecs were celebrating the festival of their war god **Huitzilopochtli**. Terrified by the extent of the human sacrifice they witnessed during the celebrations, Alvardo's men turned on the Aztecs and slaughtered as many as 10,000 priests and worshippers. When Cortés returned to Tenochtitlán, he found the city in a state of open warfare. He tried to calm the situation by making Montezuma talk to his people, but the Aztecs stoned their king to death.

Cortés then grabbed as much gold and treasure as his men could carry and tried to escape. The Aztecs ambushed the entourage and Cortés escaped with just 500 men. In a monumental tactical error, the Aztecs did not pursue the Spaniards. This gave Cortés valuable time to regroup, after which he turned back and laid siege to the city.

The Aztecs put up fierce resistance. For months they starved and suffered. Finally they were defeated by an epidemic of smallpox brought by one of Narváez's soldiers, which killed Montezuma's successor, his brother **Cuitlahuac**. Their cousin **Cuahtemoc** took over as emperor, but he was captured and tortured until he revealed fresh sources of gold. Later he was hanged on the pretext of treason against Charles V.

Many of the priests and Aztec soldiers preferred to die rather than surrender to the Spanish. So, to quell any resistance, Cortés demolished Tenochtitlán, building by building, using the rubble to fill in the city's canals. The surviving Aztecs were used as slave labor in the gold and silver mines. They were further decimated by two more epidemics of smallpox, and forcible conversion to Christianity destroyed all that remained of their culture.

What little we know of the Aztecs comes from Cortés and his men, who were more interested in booty than scholarship, and the Franciscan friar **Bernardino de Sahagún**, who questioned survivors of the onslaught in an attempt to learn something of the culture that had been destroyed. His work was inhibited by the Inquisition, which investigated him for being pro-Indian and confiscated his writings, although these, fortunately, resurfaced in the 18th century.

Despite the demise of the Aztecs, however, they can still speak to us today through the buildings, monuments, sculptures, codices, and fine art work they left behind.

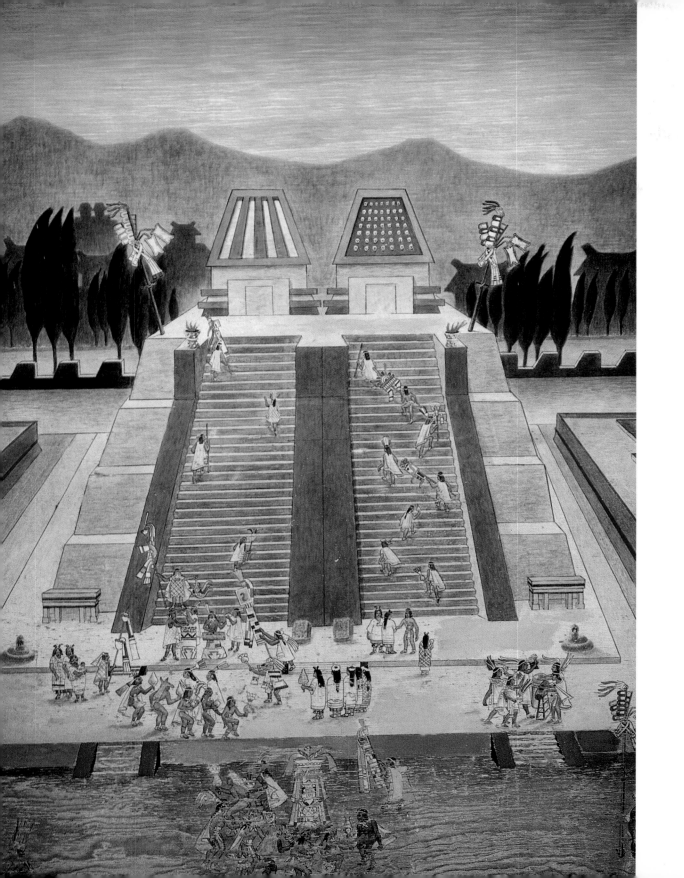

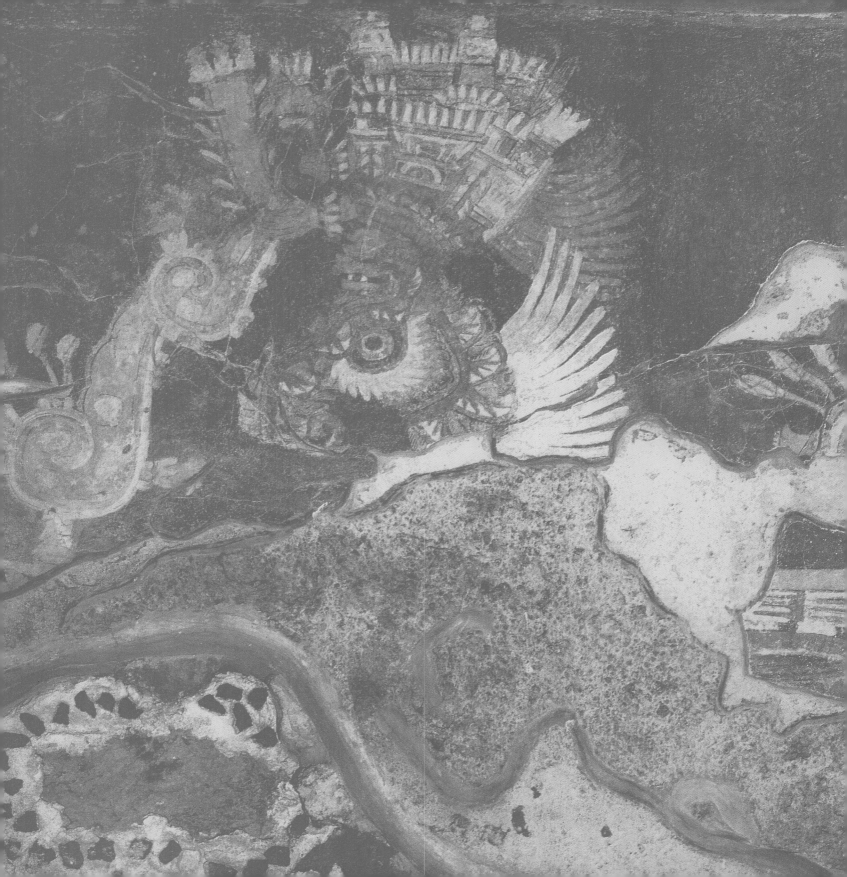

# WHO WERE THE AZTECS?

# 1

▼ **Monte Albán artifact**
Urn in the guise of a participant in a ritual ball game.

The Aztecs were latecomers to Mexico. Indians had been living in **Mesoamerica**–that is, southern Mexico and Guatemala–since 20,000 B.C., and three major civilizations and several minor ones had risen and fallen before the Aztecs came along.

The first of them was the **Olmec** civilization, which lasted from around 1200 to 500 B.C. It was founded on warfare, and the Olmecs erected huge and surprisingly realistic monumental sculptures to their warlords, in particular colossal heads.

Next came the **Teotihuacán** civilization, which lasted from 200 B.C. to A.D. 750. The city of Teotihuacán was situated in the Valley of Mexico and covered 25 miles (40 kilometers) square. It was built on a grid plan and was dominated by two huge pyramids–features which the Aztec city planners were later to adopt as their own. The Teotihuacáns left very little in the way of sculpture. Their major art form seems to have been mural painting.

The **Monte Albán** culture, based at Oaxaca, had also risen during the Teotihuacán period and another culture grew up in Veracruz. Both produced terra cotta. The **Veracruz** civilization also carved stone and developed the ritual ball games so beloved by the Aztecs.

The **Mayan** civilization lasted from A.D. 300 to 900. It was based in a number of city states in Guatemala and the Yucatan. The Mayans developed mathematical, astronomical and writing systems, although much of this is lost.

During the decline of the Maya, the **Xochicalco** civilization flourished in Morelos. The main temple there was decorated with the feathered serpent, which the Aztecs later took as their own. The Aztecs considered Xochicalco to be a mythical place and were influenced by much of its art.

The Xochicalcoans were not strong enough to resist a new influx of peoples from the north. First came the **Toltecs**. They established themselves at **Tula**, another city that the Aztecs took as a model. The Toltec civilization collapsed around the end of the 12th century for reasons unknown.

Power then devolved back to independent city states, and a new "international" style of art spread throughout the region. It was called **Mixteca-Puebla** and originated from the area around the city of Cholula. Its influence can clearly be seen in Aztec codex painting and pottery decoration.

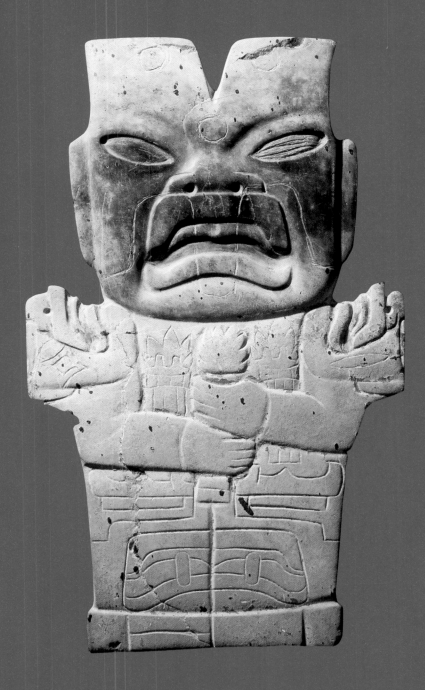

◄ **Olmec artifact**
Jade figurine of a jaguar spirit.

▼ **Mayan artifact**
Vase depicting prisoners after a battle.

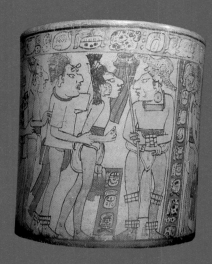

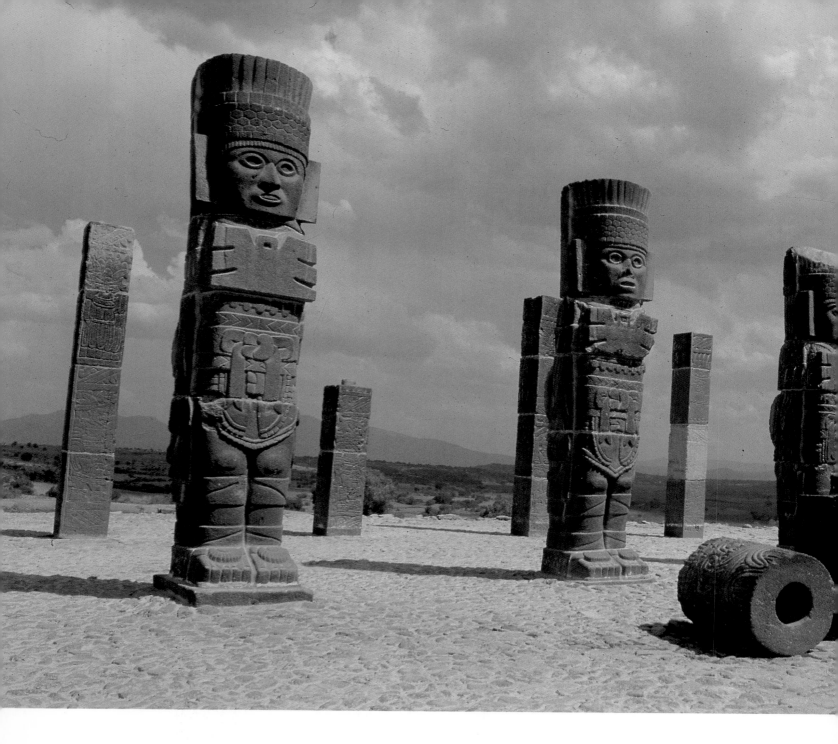

▲ **Toltec stone warrior figures**
The figures were originally columns supporting a pyramid dedicated to Quetzalcoatl.

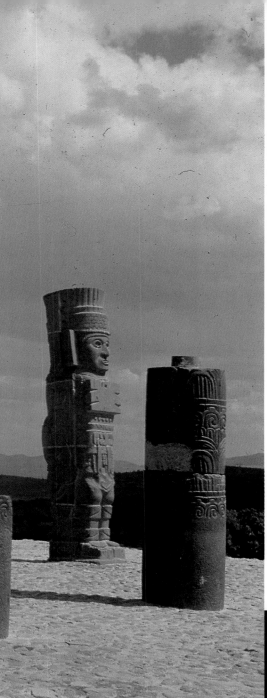

Next came the **Mexica**, who eventually became the **Aztecs**. Their civilization took root in the 13th century. They saw themselves as the heirs to the Toltecs, excavated the ruins of Tula, and took the statues they found back to their own capital, Tenochtitlán. Aztec rulers often claimed to be descendants of the Toltec royal family in order to establish their right to rule. The Aztecs also incorporated the artistic styles developed in Veracruz and Xochicalco into their own and built monumental sculptures dwarfed only by those of the Olmecs.

In 1428, the fourth ruler of Tenochtitlán, **Itzcoatl**, defeated the Tepanec, then the most powerful group in the Valley of Mexico, by forming the **Triple Alliance** with the cities of **Texcoco** and **Tlacopan**. This alliance gave Tenochtitlán military power over Texcoco and Tlacopan and was the foundation of the Aztec empire.

Itzcoatl laid the plans for a major reconstruction of Tenochtitlán, which was carried out by his successor Montezuma I. Itzcoatl also ordered the burning of books in Tenochtitlán, rewriting the past to suit his own needs. According to his new version of history, the people of Tenochtitlán were the people chosen by the war god Huitzilopochtli to uphold the cosmic order through warfare and sacrifice. They came from **Aztlán**—a "place of whiteness"—which gave them their name Aztec. Attempts to find Aztlán, which was thought to have been in northwest Mexico, have failed. This is probably because it did not exist outside the mind of Itzcoatl.

▼ **Toltec shell mosaic**
Quetzalcoatl rising from the jaws of a coyote.

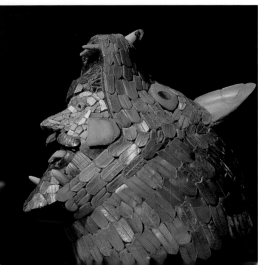

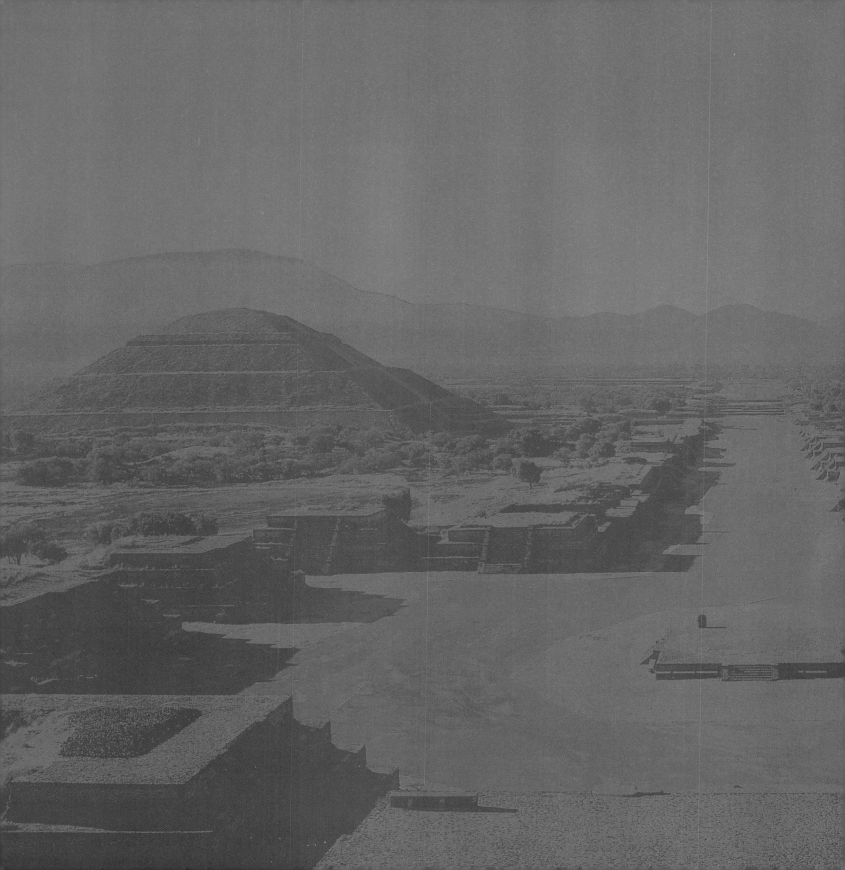

ARCHITECTURE

2

Little Aztec architecture remains. The Aztec capital **Tenochtitlán** was almost completely destroyed by Cortés; 1 square mile (2.5 square kilometers ) in the center of the city was laid waste by his army. Eventually Mexico City sprang up over the remains of Tenochtitlán, making archaeological reconstruction impossible.

However, in 1900, when a burst sewer pipe was being repaired, the corner of the Tenochtitlán's main temple was discovered. More excavation took place in 1915 and 1934. In 1978, a large stone sculpture was unearthed. This prompted the **Instituto Nacional de Antropología e Historia** to clear the stairway of the main pyramid, removing a colonial building in the process. Tenochtitlán's twin city **Tlatelolco** was excavated from 1945 to 1965, before that area of Mexico City was built up. A large temple was reconstructed in the **Plaza de las Tres Culturas**. Later, the digging of the Metro underground railway system gave archaeologists another chance to study the old city. From these excavations and Aztec records, it has been possible to piece together the architectural history of the area.

In the 14th century, Tenochtitlán was just a small village in the middle of **Lake Tetzcoco**, which itself lay at the center of the Valley of Mexico. The people who settled there were Mexica fishermen and soldiers who hired themselves out to the **Tepanecs**, then the strongest nation in the valley.

As the power of the Tepanecs grew, the Mexica soldiers shared in the spoils of war and Tenochtitlán began to expand. Causeways and canals were built to increase the limited area of the islands, slowly turning Tenochtitlán into the Venice of the Americas. Drinking water came from springs on the mainland via an aqueduct that the Mexica built.

**Tenochtitlán** ▶
A plan of the great city by Lake Tetzcoco.

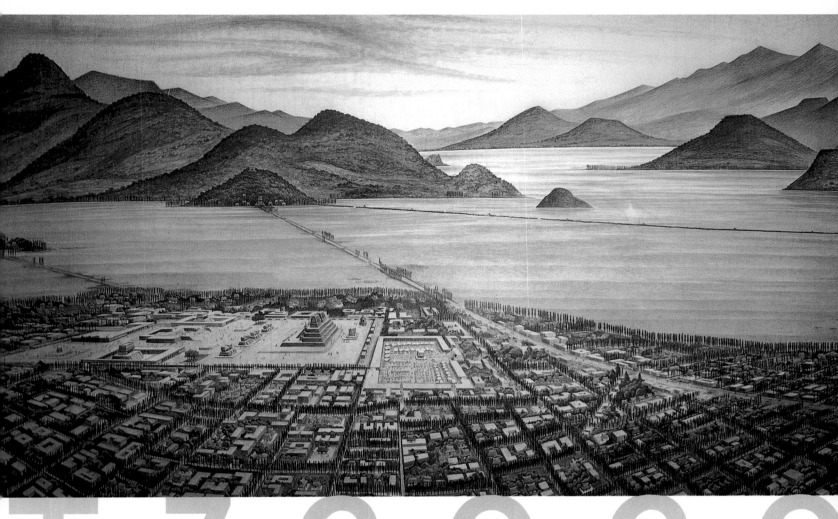

T Z C O C O

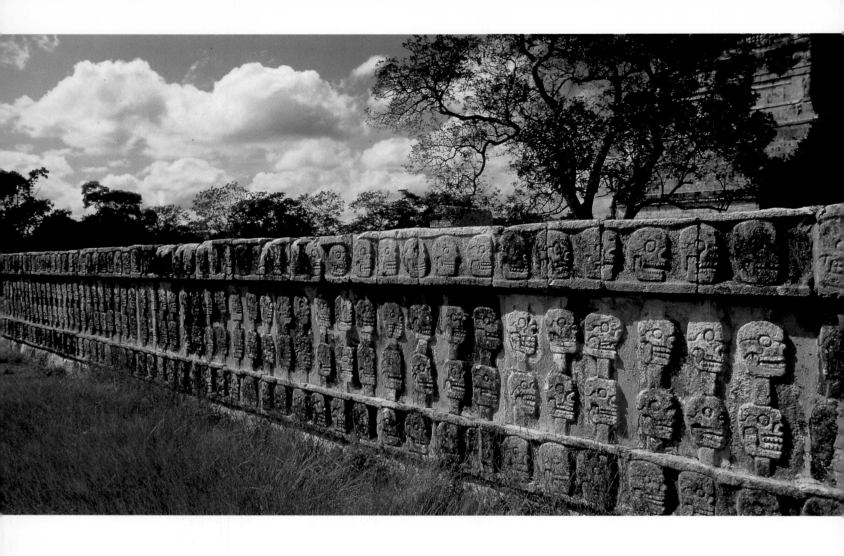

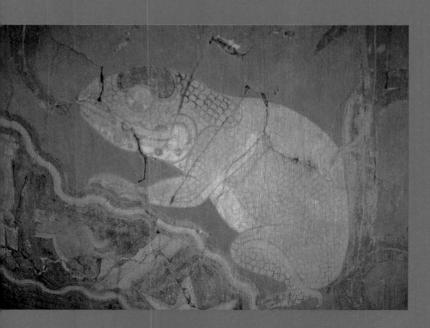

When the Tepanecs were beaten by the **Triple Alliance** formed by the cities of Tenochtitlán, Texcoco, and Tlacopan, Tenochtitlán became the most powerful city in the valley. Conquered peoples were used to build a causeway 5 miles long and 130 feet across (8 kilometers by 40 meters) connecting Tenochtitlán and Tlatelolco, a city established by merchants on an island to the north. A road along the causeway was flanked by two canals.

There was a great rivalry between Tenochtitlán and Tlatelolco and, less than three years after the causeway had been completed, a barrier was built dividing the two cities. In the 1470s, a war broke out, ending in defeat for Tlatelolco, which was annexed by the ever-expanding Tenochtitlán.

Under **Montezuma I (1441–1469)**, Tenochtitlán was rebuilt. He commissioned huge stone palaces and encouraged noblemen to build two-story houses of their own. The construction was undertaken by **Chalcan** women. The Chalcan were renowned masons but, when the Aztecs had conquered them, most of their menfolk had been slaughtered.

An 8½-mile (14-kilometer) dyke was built to protect the city from flooding and, as the city was being rebuilt, the ground level was raised for the same purpose. This was carried out under the guidance of **Nezahualcoyotl**, the king of Texcoco, a city which had once had flooding problems of its own. A new aqueduct was built too.

A magnificent new **Temple of Huitzilopochtli** was begun by Montezuma's successor **Tizoc** and completed by his successor **Ahuitzotl**, who dedicated its sacred precinct to the war god with the sacrifice of thousands of people who had been captured during his military campaigns.

For the **New Fire Ceremony** in 1507, **Montezuma II** rebuilt the **Hill of the Star** temple near Culhuacan. He contributed a famous zoo and a new palace to Tenochtitlán. It was a two-story building and covered over 260,000 square feet (24,000 square meters). Plans show that it had five huge rooms with 20 massive doors opening out onto a central courtyard.

Montezuma's palace was the seat of government as well as his home. It had a war room as well as an area where conquered nobles and local headmen would receive orders. Servants and resident artists were also housed in the palace, along with numerous concubines.

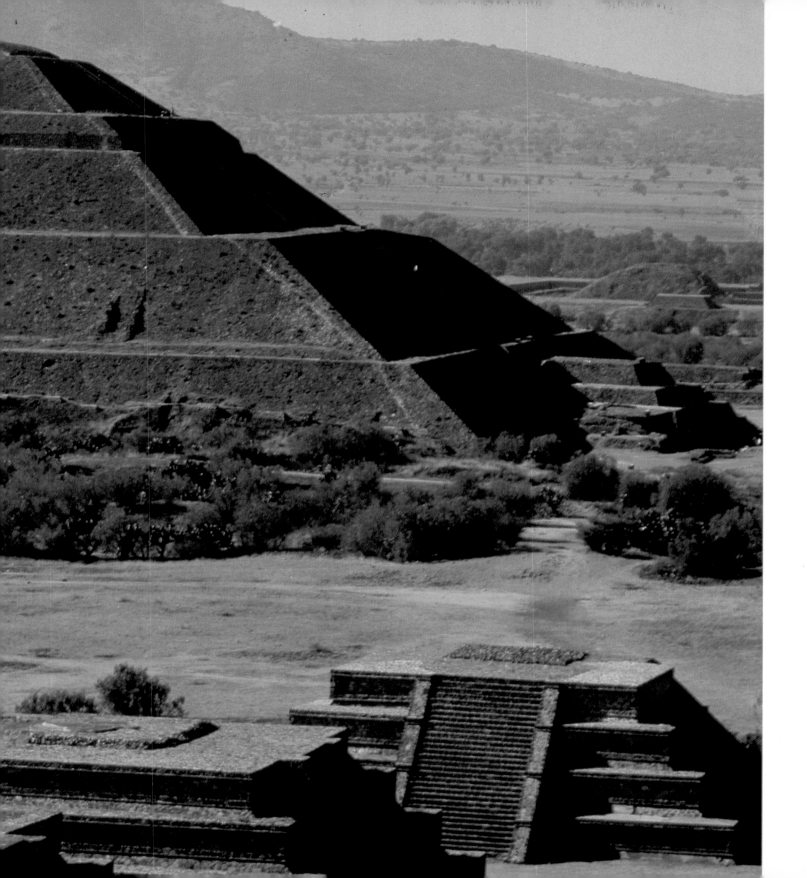

The floors were covered with mats. Other mats trimmed with little gold bells were hung in the doorways so that the occupant would be alerted if anyone approached.

Tenochtitlán was built on a grid pattern with five major canals running east–west across the city. Drainage patterns meant that the north–south canals were not so regular. The city was divided into four quarters and subdivided into nearly 100 districts, each with its own temple and warrior's house. This grid plan and the architectural style of Tenochtitlán were derived directly from the city of Teotihuacán that flourished in the northeast Valley of Mexico from 200 B.C. to A.D. 750. As the city had long since been abandoned, the Aztecs had no knowledge of its inhabitants. They believed that the gods had gathered there when the world was created.

At Teotihuacán, the grid pattern lies 15° east of north. Although the Aztecs had surveyed Teotihuacán, they laid down the grid for Tenochtitlán 17° east of north, so that it faces sunrise over **Mount Tlaloc** on the summer solstice.

The ruins of Teotihuacán are dominated by two major pyramids along with a number of platforms in a central ceremonial precinct. This is surrounded by a residential area.

Tenochtitlán had a similar layout. The homes were built in walled compounds along side streets. They were arranged around a central patio and were occupied by several interrelated families. Outlying houses were thatched and the compounds made of wattle. The more prosperous inhabitants of the city had terra-cotta roofing tiles.

Like Teotihuacán, Tenochtitlán was built around a temple precinct, spread over 1,300 feet (400 meters) square and walled with four gateways leading to the streets. There were a number of temples in the precinct. These were dedicated to **Huitzilopochtli** the war god,

▲ **The Pyramid of the Sun** (previous page)
Built in the 2nd century B.C. at Teotihuacán.

▶ **Temple of the Warriors**
Sculptures on the stairway at Chichén Itzá.

▼ **Chacmool figure**
Discovered in the ruins of Tenochtitlán.

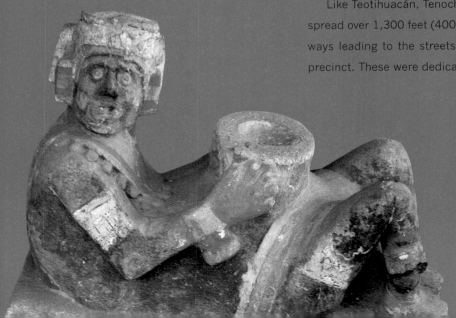

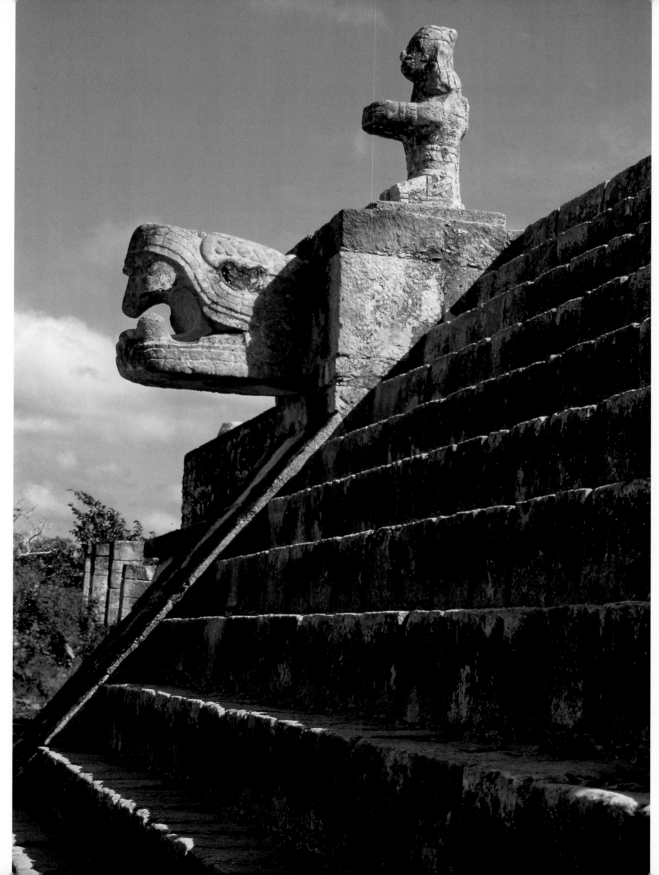

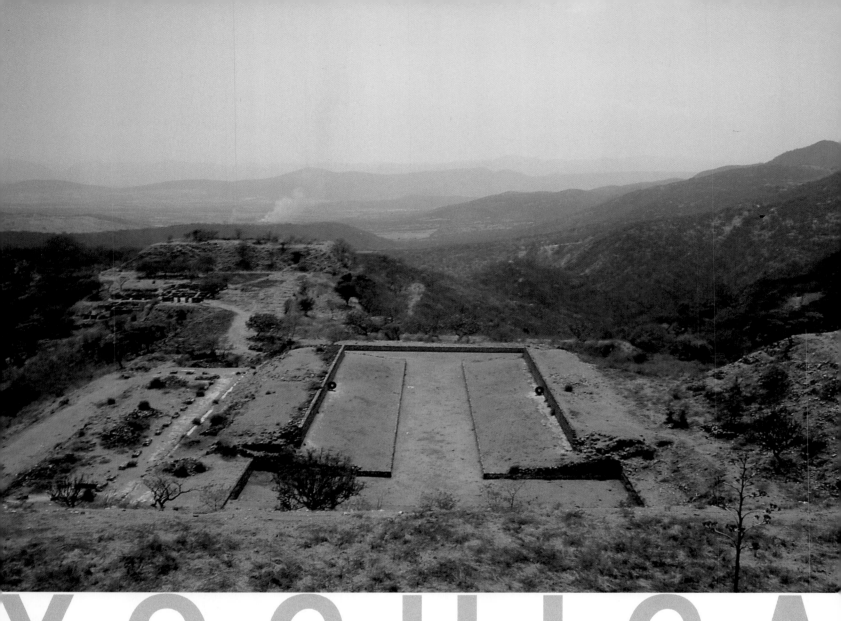

XOCHICA

**▲ Ball court at Xochicalco**
The ball game was played for both sporting and ritual purposes.

Tlaloc the Aztec rain god, and Cihuacoatl the goddess of the earth, usually depicted as a woman-snake. Alongside the temples were a ball court, a platform for gladiatorial sacrifices, and a skull rack, where the heads of sacrificial victims were piled.

The **Temple of Huitzilopochtli** had a large stone in the doorway, which was probably used for sacrificial rituals. In its place in the **Temple of Tlaloc** was a chacmool, a reclining male figure holding a dish on his stomach, and painted in red, blue, black, yellow, and white. Chacmool figures also appear at **Tula** and the Mayan city **Chichén Itzá**. The walls of the temple were covered with murals, together with carvings of snakes' heads, feathered snakes, and frogs.

The roof of Huitzilopochtli's temple was decorated with skulls. In front, there was a spring feeding a pool of water. On the front stairway, there was a round relief showing the dismembered body of **Coyolx-auhqui**, the moon goddess who, with her brothers, the 400 stars, plotted to murder their mother **Coatlicue** after she had conceived Huitzilopochtli. But when Coatlicue died, Huitzilopochtli emerged from her belly fully grown and armed. He slaughtered the stars and killed and dismembered the body of Coyolxauhqui. Cosmologically, this explains how the sun seems to extinguish the stars and the moon. It is also a symbol of how the Aztecs suppressed their enemies.

The **Temple of Cihuacoatl**, the earth goddess, was not built on a plinth like the others, but was a low cavelike crawlspace said to be symbolic of the womb. It is thought that statues looted from enemy temples were kept "prisoner" there, and items from all over the Aztec empire have been found in these temples.

The skull racks were made of wood supported on masonry. On the gladiatorial platform there was a circular carved stone. During the feast of the flayed god **Xipe Totec**, captives were tied to the stone. With only a feather to defend themselves, they were set upon by Aztecs wielding war clubs made of obsidian.

While the temple precinct at Tenochtitlán has been destroyed and built over, some of the precinct at Tlatelolco remains intact. There, the main twin pyramid is surrounded by a series of smaller temples. One of these has a set of niches around the sides containing reliefs and glyphs. Nothing, however, remains of the round building with a door shaped like a fanged mouth that Cortés recorded, but a round plinth has been found on the site.

▼ **Relief from the Temple of Huitzilopochtli**
The dismembered body of the moon goddess Coyolxauhqui.

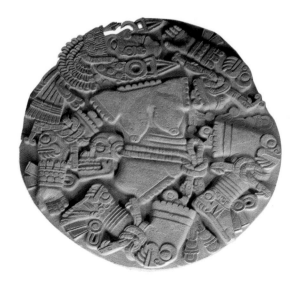

Another round plinth seated atop a square one was unearthed at **Piño Suarez** Metro station. Two statues were also found there. One is a seated god with two horns; the other an ape-like figure holding a snake. These, like all Aztec sculpture, follow the style of the Toltecs, the inhabitants of Tula between the 9th and 11th centuries A.D.

Other surviving Aztec cities are built according to the same plan as Tenochtitlán, although the central compound in **Cempola** is not rectangular but trapezoid, and **Huexotla** has a fortified wall around it which is missing at Tenochtitlán and Tlatelolco.

Aztec temple design was also standardized. Many cities had over one hundred temples and **Cholula** had one for every day of the year. Temples were basically tall platforms, triangular in cross-section with sides in the form of broad stairways. The balustrades became higher toward the top and formed small terraces where incense burners or standard bearers could stand.

The major temples are usually twin pyramids with one butted directly up to the other. This meant that conquered peoples could continue to worship their old gods, while at the same time worship the war god **Huitzilopochtli**, which the Aztecs forced them to do.

Temples were often expanded by building a new shell over the existing pyramid. The twin pyramids at **Tenayuce**, for example, were enlarged six times. At Tenayuce snakes and snake heads were built along the side walls. These were painted black along the north wall, blue along the south, and half black, half blue along the west.

The shrine on the summit of the temple was set back so that there was room to make human sacrifices in front of them. The shrine itself was simply a single room. The outside walls, however, were covered

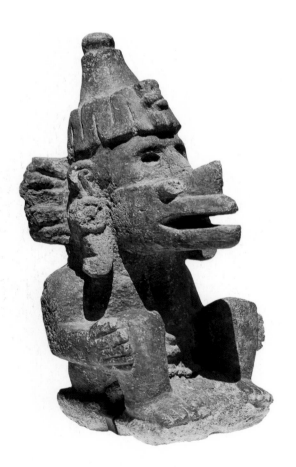

◄ **The wind god Ehecatl**
The Aztecs depicted the wind god with extended lips.

► **Ball-game ring, Chichén Itzá**
The ritual game ended when the ball was pushed through the stone ring.

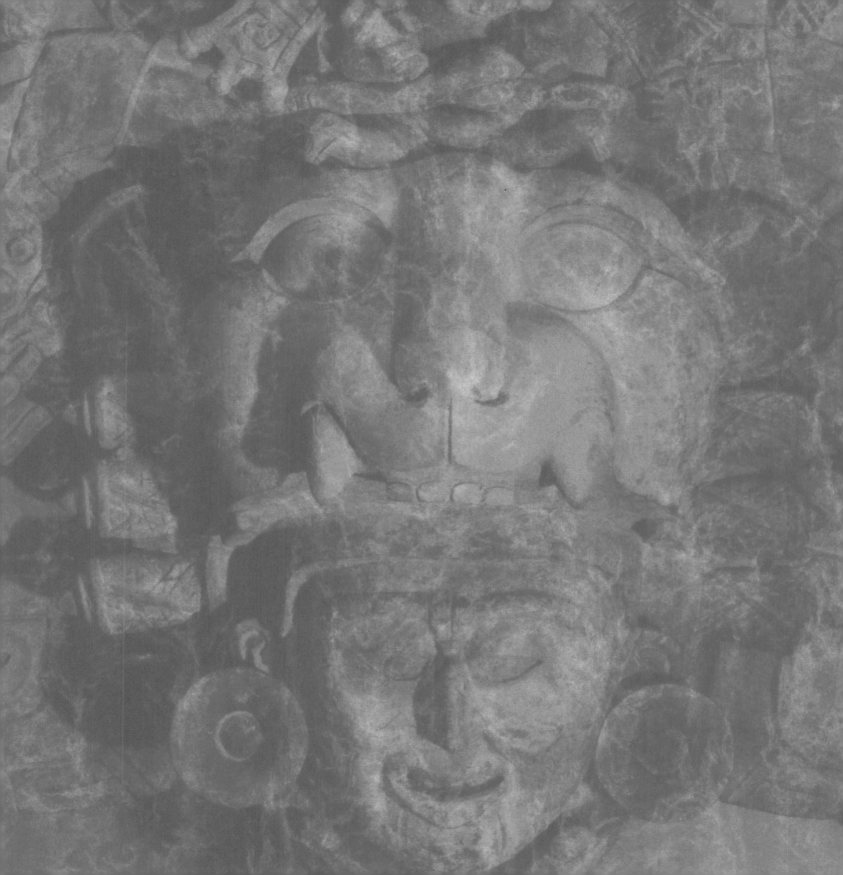

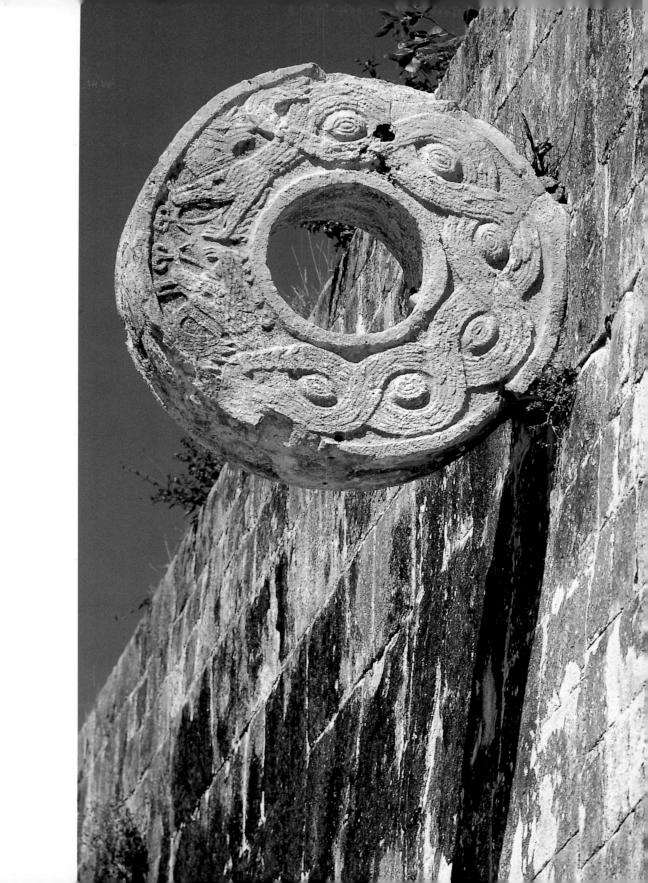

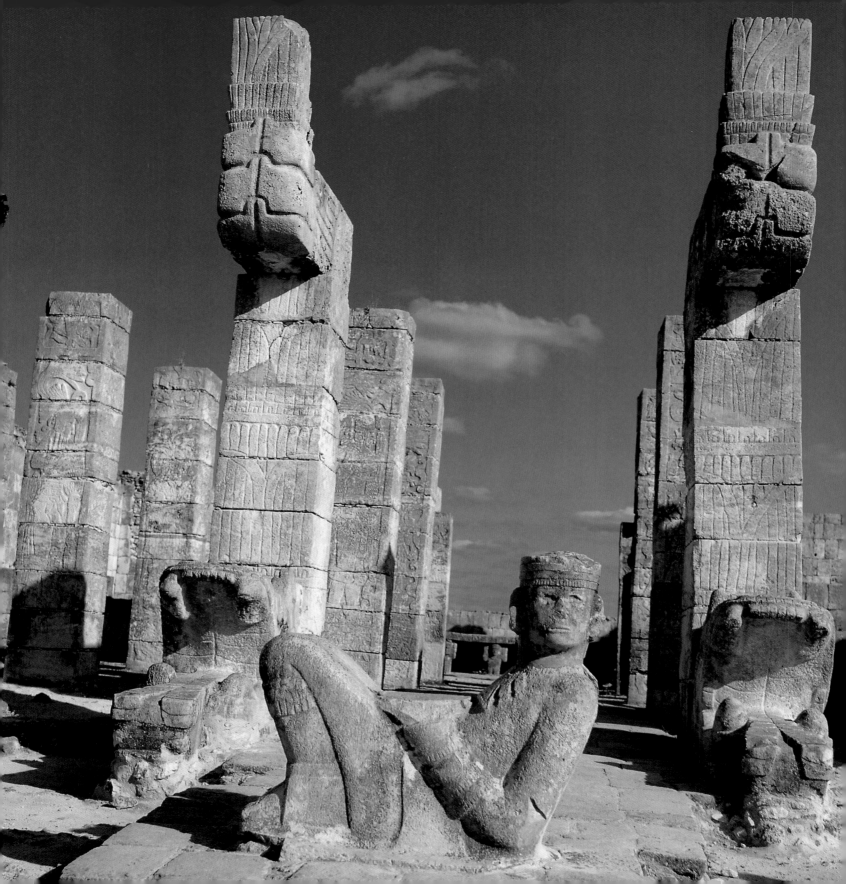

with plaster which was painted and burnished so brightly that the conquistadors thought they were made of silver.

The round buildings that Cortés saw were built later. They are thought to have been associated with the worship of the wind god **Ehecatl**, as a statue of a standing male god with extended lips was found inside the ruins of a round building at **Calixtlahuaca**. The doorway took the form of a snake's mouth and is thought to have symbolized the entrance to the underworld.

**Ball courts** were also found in the central ceremonial areas. These were I-shaped, with the spectators standing on top of the high walls looking down on the game. The game had ritual as well as sporting significance. In addition to being played for entertainment and gambling purposes, ball games also formed part of religious rituals, with players being sacrificed to the gods. The game was played with a solid rubber ball that could not be touched with the hands or feet. Using only the elbows, knees, and hips, the teams tried to prevent the ball from bouncing in their side of the court. The game ended when the ball was shoved, with the hips, through the hole in the middle of a circular stone. A number of these ball-game rings have been found.

◀ **Temple of the Warriors, Chichén Itzá**
Chacmool figure at the entrance to the inner temple, flanked by serpent columns.

▼ **Coatlicue, the Aztec earth mother**
One of a pair of colossal statues from the courtyard of the temple at Tenochtitlán.

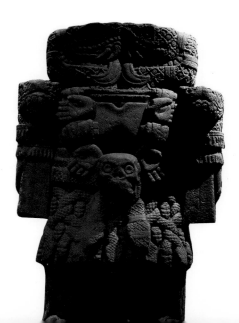

# MOUNTAIN SHRINES
# AND CLIFF RELIEFS

TLALOC

As well as free-standing temples, the Aztecs also built mountain shrines, sometimes carving a complete temple into the side of a hill. At **Mount Tlaloc** there was a shrine to the rain god Tlaloc, usually depicted as a standing figure with a bowl on his head. A child sacrifice was last believed to have taken place there in the 19th century.

Rock sculpture had a prominent place in Aztec culture. To the east of Tenochtitlán was a nature shrine with reliefs carved into the volcanic rock. Sadly, the reliefs have been destroyed, but we know that one showed the god **Tezcatlipoca** holding a victim by the hair. Tezcatlipoca, the so-called "smoking mirror," was the god of chance, destiny, and divination. The mirrors in his headdress were used to foretell the future, and he had a smoking mirror in place of his left foot, which was lost in a battle with the earth monster during the creation of the world. Tezcatlipoca seizing a victim by the hair symbolized the Aztecs' destiny to rule over the world.

Reliefs carved into the cliffs above the ruins of Tula show the legendary leader of Tula, **Quetzalcoatl**. The reliefs are not Toltec but Aztec. Quetzalcoatl is shown drawing blood from his ear, which formed part of the coronation ceremony of the Aztec rulers. Next to Quetzalcoatl is the figure of a maize-water goddess, who is probably the local spirit of the mountain.

The mountain shrine at **Chapultepec** was destroyed, although a statue of Tlaloc has been unearthed there. Aztec rulers had their portraits carved into the rock at Chapultepec, but only one showing Montezuma II and a fragment of another survive. Montezuma II is depicted nearly lifesize in the costume of the flayed god **Xipe Totec**, which was the king's military uniform. He was 52 years old at the time, the equivalent of a century in the Aztec calendar. The relief took 14 stone carvers 30 days to complete.

To celebrate his 52nd birthday, **Nezahualcoyotl** began to build a garden shrine on a hill at **Tetzcotzingo**, a short distance to the southeast of his capital **Texcoco**. The shrine was fed by an aqueduct and features a number of circular pools carved into the rock. Three one-roomed temples with thatched roofs were cut into the rock and decorated with reliefs. It is thought that Nezahualcoyotl and his son **Nezahualpilli** had their portraits carved in the rock there, but the feet and a fragment of a headdress are all that remain. By the pools there are carvings of frogs. A relief of Tlaloc stands on the top of

◄ **Tlaloc**
The rain god, typically portrayed with a pleated fan behind his head.

▼ **Xochiquetzal**
The goddess of drunkenness and sexuality.

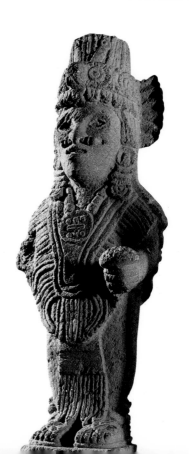

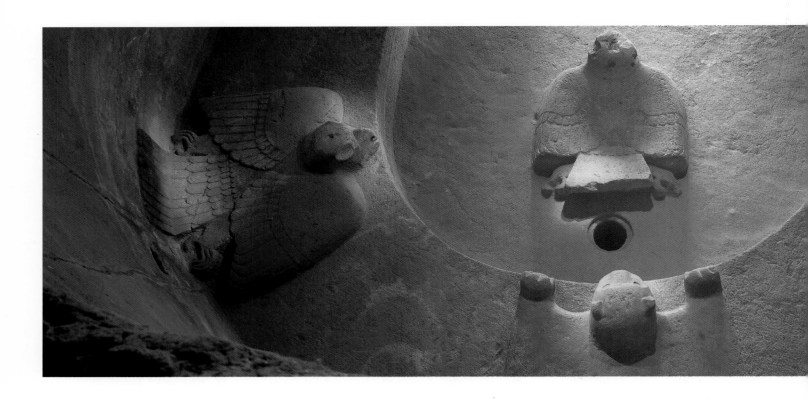

▲ **The main temple at Malinalco**
Rock-cut interior featuring three eagles and a jaguar, both creatures symbols of war.

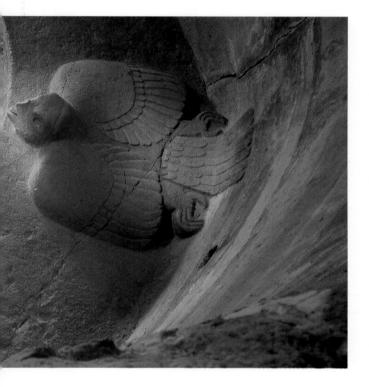

the hill and numerous monkey-headed water spouts found elsewhere in Mexico are thought to have come from Tetzcotzingo.

Two thousand feet (600 meters) above the village of **Tepoztlan,** there is a temple with a veranda and a number of reliefs. These show the mythical beast known as **ahuitzotl**, whose name is derived from a combination of the Aztec emperor, fertility gods, and the gods of pulque, the local drink. There is also a depiction of **Xochiquet-zal**, the goddess of drunkenness and sexuality.

At Malinalco, in one of the best-preserved Aztec shrines, there are sculptures of extravagantly dressed women, which is unusual for the spartan Aztecs. Nearby, at **Acatzingo**, there is a cliff relief showing a naked woman sitting cross-legged with her genitals exposed. This is unique, as the Aztecs were, in general, a prudish people.

Eagles, jaguars, and monstrous snakes also appear in the reliefs of the rock-carved temple at **Malinalco**. These are symbols of war and no doubt had propaganda value, as the temples at Tepoztlan and Malinalco were built before the area was annexed by the Aztecs.

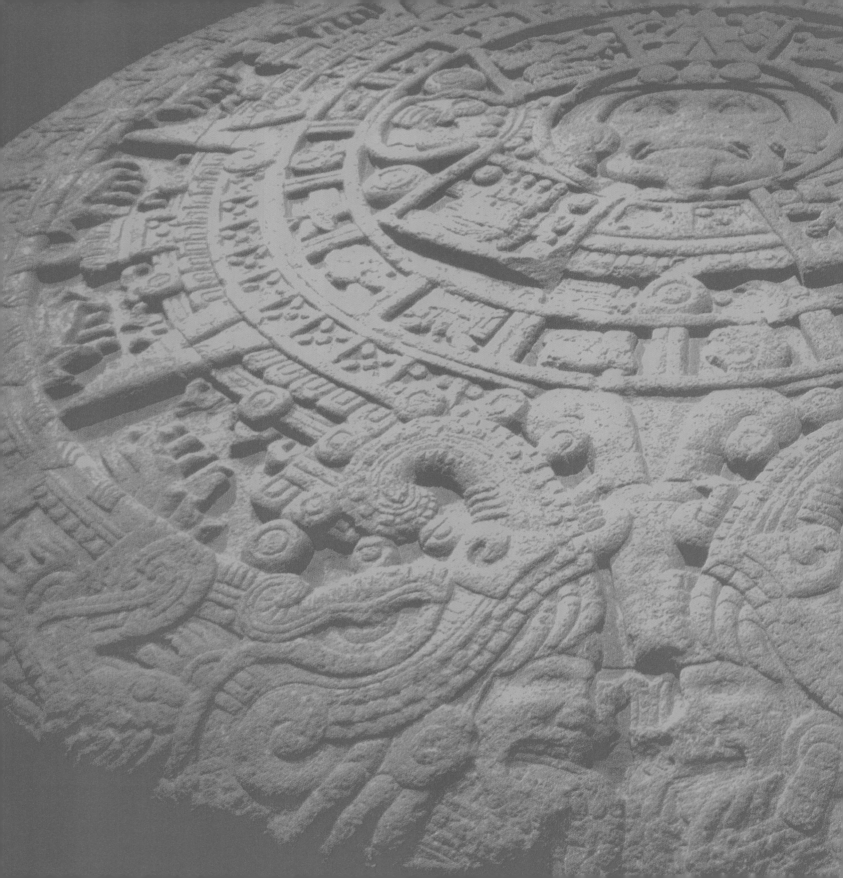

# SCULPTURE

# 4

The Aztecs' main form of artistic expression was sculpture. Unfortunately, the invading Spaniards saw Aztec statues as the work of the devil and destroyed them. Very few survived.

However, we do know that the monumental sculptures of Tenochtitlán were huge, sophisticated, and beautifully finished. There were two basic types: idols–none of which survived from Tenochtitlán–and carved stones used in sacrificial ceremonies.

The idols were carved from stone or wood and were often covered with gold, silver, pearls, and precious stones stuck on with a paste made from ground roots. Those statues that have survived from places outside Tenochtitlán lost their valuable coating long ago.

Most statues depicted Aztec gods and were to be found not only in temples but also in shrines in Aztec households. The various gods and goddesses are often hard to distinguish from one another. For example, **Chalchiuhtlicue**, the goddess of rivers and lakes, and **Chicomecoatl**, the goddess of maize, wear the same headdress. Originally, the two goddesses would have been distinguishable from each other because Chalchiuhticue would have been painted blue and Chicomecoatl red. But now that the paint has gone, it is almost impossible to tell which is which.

**Quetzalcoatl** was the most widely depicted of the gods. He was one of the four creator gods and was associated with the planet Venus. He was the god of learning and the priesthood, and the god of twins, who also manifests himself as the wind god Ehecatl. As the legendary priest-king of Tula, Quetzalcoatl was opposed to human sacrifice, but he was driven from the city by the magician Tezcatlipoca. Escaping into the Gulf of Mexico on a raft of serpents, he was supposed to return in the year I Reed according to the Aztec calendar.

In statues, Quetzalcoatl is depicted rising like the morning star from the jaws of a feathered serpent, or as the feathered serpent itself. In Nahuatl, the Aztec language, **"quetzatlli"** means both feathers and precious, and **"coatl"** means serpent and twin. Quetzalcoatl had his own malevolent twin, the deformed god **Xolotl**, who is often depicted with the head of a dog.

As **Ehecatl**, Quetzalcoatl represents both the wind and the breath of life itself. He is the "Sweeper of the Skies," the precursor of rain and is, thus, associated with fertility. Ehecatl appears with a conical hat or coiled hair and a protruding, beak-shaped mouth.

▶ **Quetzalcoatl**
Stone relief depicting the god's birth.

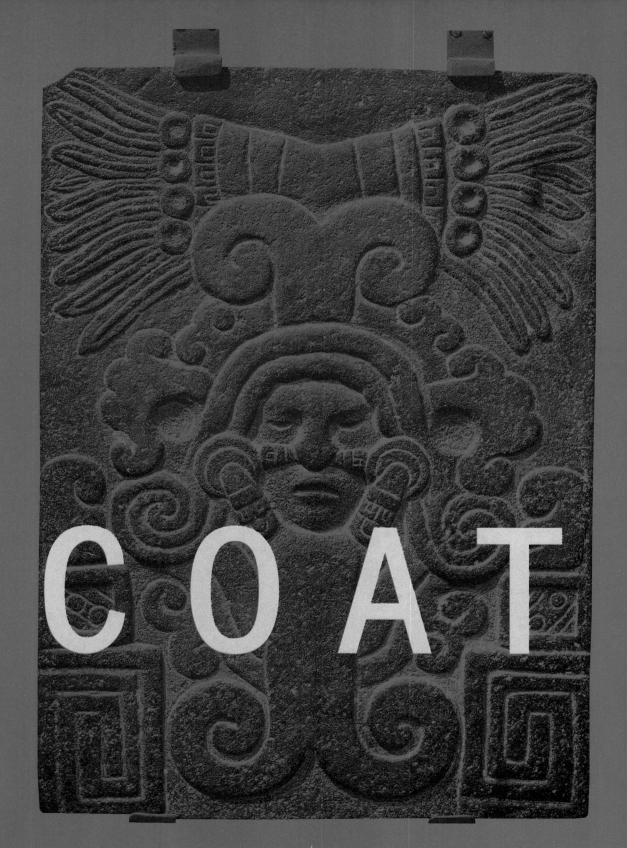

LCOATL

Many statues of **T l a l o c**, the rain god, survive. The Aztecs ranked him equal to their god of war **Huitzilopochtli**. Statues of Tlaloc show him with snakes coiled around his eyes and mouth to form a mask. He has fangs and is always shown wearing a pleated paper fan at the back of his head, ear plugs, and a headdress set with precious stones.

**Chalchiuhtlicue**, the goddess of rivers and lakes, is closely associated with Tlaloc. She is variously described as his mother, sister, and wife. Both she and Tlaloc were believed to be dangerous when angered, bringing droughts or floods, and therefore had to be appeased. She is portrayed as a young woman wearing a three-banded headdress fringed with discs. She often wears a paper fan, traditionally painted blue, in her hair. Her likeness was frequently carved in jade, as her name means **"Lady of the Jade Skirt**."

The flayed god **Xipe Totec** was another of the four creator gods and was associated with fertility, the spring rains, and new growth. He was also the patron of goldsmiths and jewelers, so his statues were richly adorned. The cult of Xipe Totec was particularly savage and his priests often wore the flayed skins of their sacrificial victims. In statues, Xipe Totec is frequently shown wearing a flayed skin too. His face is round and bloated, with eyes closed and mouth hanging open, symbolizing death. Many of Xipe's death masks survive.

Three maize deities were also depicted. The overall god of the maize, **Centeotl**, was male, although maize itself was thought of as female. The young goddess **Xilonen** represented the young green maize, while **Chicomecoatl** represented the nourishing ripe maize. Although the three deities are sometimes depicted together, more statuettes of Chicomecoatl survive than any of the other fertility deities. Traditionally her statues were painted red. She has a distinctive square headdress and carries corncobs. However, in some places she was confused with Chalchiuhtlicue, and a goddess wearing a three-banded headdress is shown holding corn cobs.

Centeotl is also associated with **Xochipilli, the "Prince of Flowers**." He was also god of the dawn, dancing, pleasure, love, and eternal youth. In statues, he is shown wearing a loin cloth and sandals and is usually depicted sitting. His headdress is made of flowers and red feathers.

**Xiuhtecuhtli** was the Aztec god of fire. In pre-Aztec times, he was represented by a temple or a domestic brazier. The Aztecs

◄ **Fountain in Mexico City**
A modern sculpture dedicated to the Aztec rain god Tlaloc.

▼ **The flayed god Xipe Totec**
The fertility god wears the skin of a sacrificial victim.

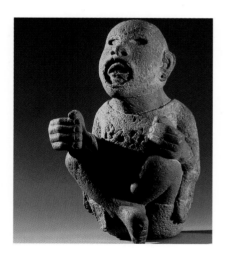

SCULPTURE

◀ **Xiutecuhtli, the god of fire**
The top of the head is hollowed out so that a fire could be lit there.

XIUTEC

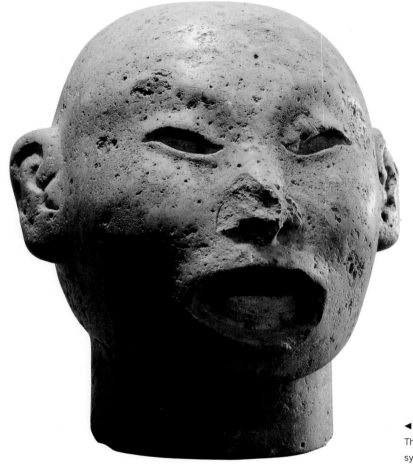

◀ **Xipe Totec death mask**
The closed eyes and the mouth hanging open
symbolize death.

UHTLI

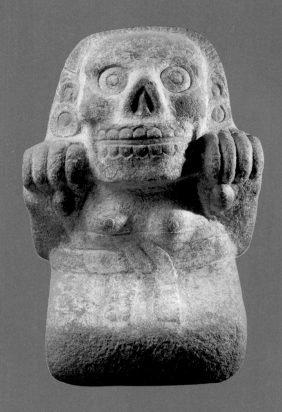

worshipped him as part of the cult of the sun and called him **Hue-huete otl**–the old god. He is often depicted as a toothless old man.

In statues, Huehueteotl wears a simple loin cloth. His headband has circles on it, symbolizing fire. The back of his head was often hollowed out so that small fires could be lit there. He also appears in the form of the fire serpent, who, according to legend, helped the war god Huitzilopochtli to defeat the moon and stars, his sister and brothers. The main temple at Tenochtitlán was said to have a **"wall of snakes,"** and wall carvings of fire serpents are common.

**Mictlantechuli** was the god of death. He ruled over Mictlan, the Aztec underworld. The souls of those who drowned or died of water-related illnesses found rest in **Tlalocan**, the paradise to the south ruled over by the rain god. Warriors who fell in battle or died at the sacrificial stone went to **Tonatiuhican** to the east, and women who died in childbirth went to a paradise in the west. Others had to take

**◄ Mictlantechuli**
The Aztec god of death.

**► Chicomecoatl**
The goddess of ripe maize.

**▼ Chalchiuhtlicue**
The goddess of rivers and lakes.

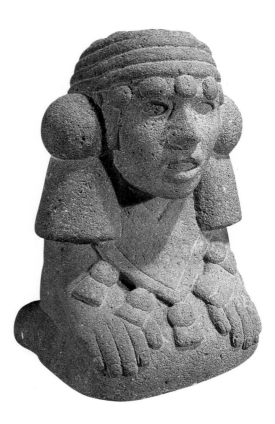

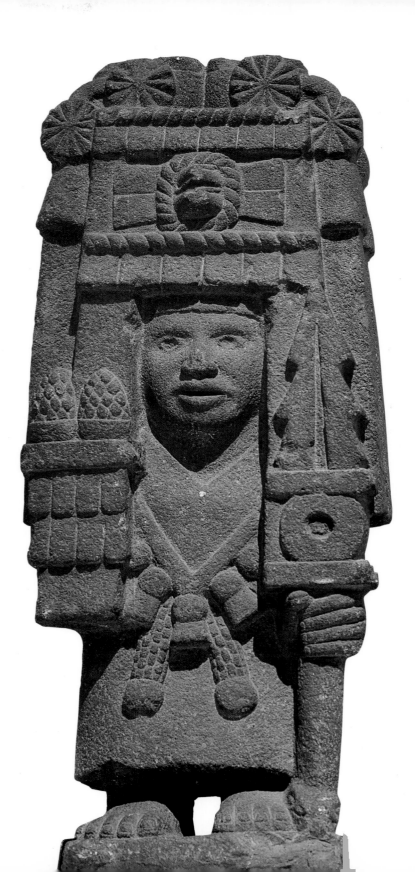

a four-year journey of suffering through nine hells before emerging in **Mictlan** at the center of the earth. Mictlantechuli is usually shown sitting and wears a skull mask and a tall conical headdress.

It is sometimes unclear whether the figures depicted in statues are the deities themselves or merely human beings wearing the insignia of the gods. However, there is a group of sculptures that definitely show the common man. These are the **macehualtin** (singular mace-hualli) who are mythologically the men created by Quetzacoatl's act of self-sacrifice. Macehualtin figures are supposed to celebrate the virtue of the peasant. Figures are carved in stone with a rectangular slit in the chest, where a piece of jade symbolizing the heart would have sat. Some show remnants of paint. The figures wear simple loin cloths and have cropped hair, distinguishing them from the nobility, who wore lavish garments and elaborate headdresses.

Macehualtin are shown either standing, sitting, or reclining. Some are deformed. The Aztecs were fascinated with deformity. Montezuma was entertained by hunchbacks, who were also an attraction at the circus. Some of the macehualtin show symptoms of tuberculosis.

Female figures are bare-breasted, wearing only an ankle-length skirt held around the waist by an embroidered belt. Women are often shown in a kneeling position.

Carved skulls are another staple of Aztec sculpture. Real skulls were kept on skull racks called **tzompantli**, but carved skulls were used to decorate pyramids and shrines. One famous piece is a translucent skull carved in rock crystal. The style of the piece would date it as pre-conquest, but one line indicates the use of a jeweler's wheel, which was only introduced to Mesoamerica by the Spaniards.

Aztec culture was built on war. Conquests were necessary to exact tribute from defeated peoples and to provide captives for the human sacrifices that the Aztecs believed were necessary to keep the sun on its daily course and to prevent the destruction of the world by earthquakes.

**Rock crystal skull** ▶
Carved skulls were used by the Aztecs to decorate temples.

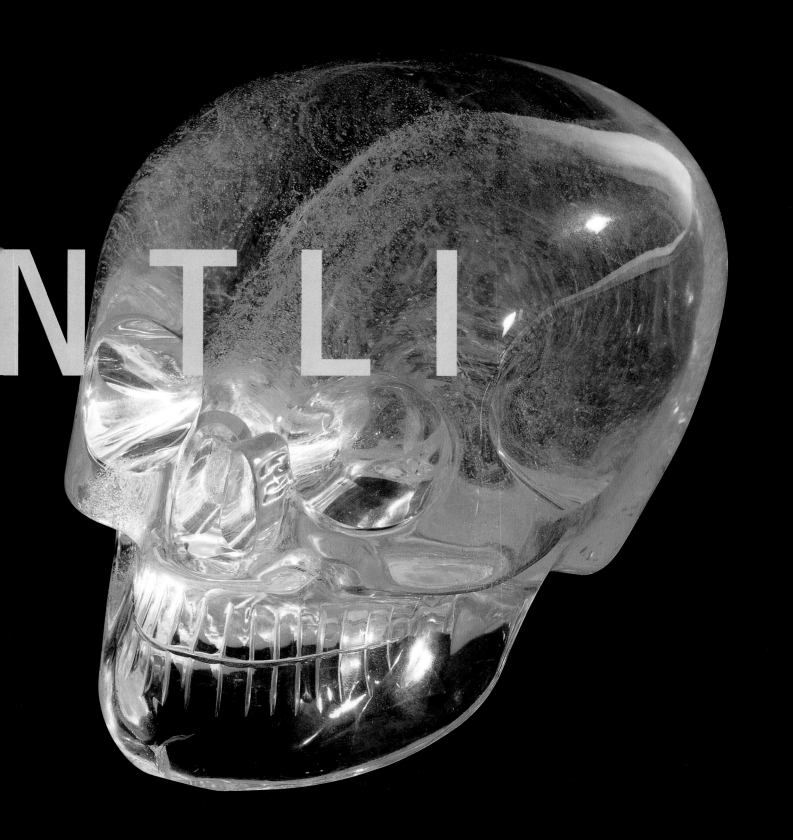

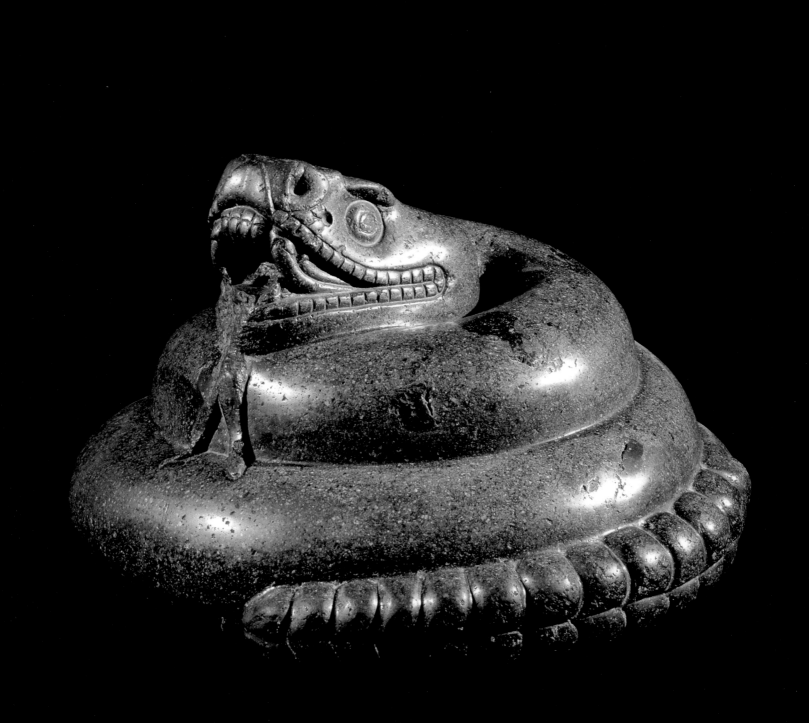

Human sacrifices were also a useful way to keep society in order. Dissidents quickly found their way to the sacrificial altars.

With a constant need for captives, war itself became a sacred duty. There were three orders of knights–**the Arrow, the Eagle, and the Jaguar**. The Arrow was the lesser order, about which little is known, but the Eagle and the Jaguar were honored for their courage and dedication. The Eagle knights were followers of **Huitzilopochtli** and the Jaguar knights of **Tezcatlipoca**. They were easily recognized by their insignia, which appear regularly as motifs. Jaguar knights are depicted wearing an ocelot skin. This was pulled over the head, so that the knight's face appeared through the animal's mouth and its skull acted as a helmet. Human faces are often shown emerging from the mouths of creatures in Aztec art.

Along with eagles and jaguars, owls, bats, spiders, and other nocturnal creatures are depicted. These are associated with the god of the underworld, **Mictlantechuli**. The owl was considered wise, but was regarded as a bird of ill omen.

Snakes are another common theme. They were a symbol of fertility and the word for snake, coatl, appears in many of the names of the gods. The name of the maize goddess **Chicomecoatl** means, for example, "Seven Serpents." The most common snake in Aztec art is the feathered serpent, **Quetzalcoatl** himself. Then there is **Xiuhcoatl**, the fire serpent. Carvings of snakes flanked the huge stairways that comprised the sides of Aztec and Toltec temples and they were used as decorative motifs in architecture.

The frog was seen as a symbol of fertility and appears in shrines to Tlaloc and Chalchiuhtlicue. The earth itself is sometimes depicted as a huge frog called **Tlalecuhtli**.

Fish were another symbol of fertility and procreation. Humankind were said to have been transformed into fish after the fourth era of creation when the earth was destroyed by a flood.

Monkeys were used to represent the arts, music, dancing, and sensual pleasure. They were also a reminder of the punishment of sexual sins. After the second era of creation, men were supposed to have been transformed into monkeys by the winds.

Dogs were also depicted. They were bred to be slaughtered at funerals so that their spirits could guide human souls through the trials they had to endure on their way to Mictlan.

**◄ Chicomecoatl**
The maize goddess depicted as a serpent.

**▼ Monkey statuette**
A servant of Xochipilli, the god of pleasure.

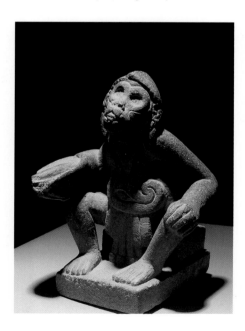

The Aztecs also carved various ritual items. The most common of those that survive are **quauhxicalli**, or eagle vessels. These were the ritual vessels used to collect the blood and contain the hearts of sacrificial victims. They often have stylized eagle's feathers around the mouth and a sun motif on the side. Usually they carry various glyphs. The most common is the glyph **ollin**, which means motion or earthquake. The Aztecs believed that if they failed to make blood sacrifices to the gods, the world would be destroyed by earthquakes. Others carry the glyph for Tlaloc the rain god and were used in blood rituals to prevent floods and droughts.

**Chacmools**, reclining figures holding a bowl on their stomach, were also widespread. First carved by the Toltecs, they stood near the

doorway to temples dedicated to the rain god Tlaloc. The bowl would have held blood or some other offering.

Carved stone boxes have also been found. Fragments of paint indicate that they were once red. They seem to have been used in funeral rites, possibly as a casket for the ashes. One may be the funeral cask of **Ahuitzotl**, the Aztecs' eighth ruler who died in the great flood after the inauguration of the disastrous aqueduct from Coyoacan to Tenochtitlán. On it, a tlaloc, one of the four lesser assistants of Tlaloc, is shown pouring water and maize from a stone vessel. This is thought to refer to the flood. An ahuizotl, a mythological water-borne monster with the body of a dog and the tail of a serpent, is also depicted.

The temple stone from the main temple at **Tenochtitlán** is the most elaborate Mexica piece of sculpture surviving and was probably the Aztec emperor's throne. Taking the shape of a temple, it has six

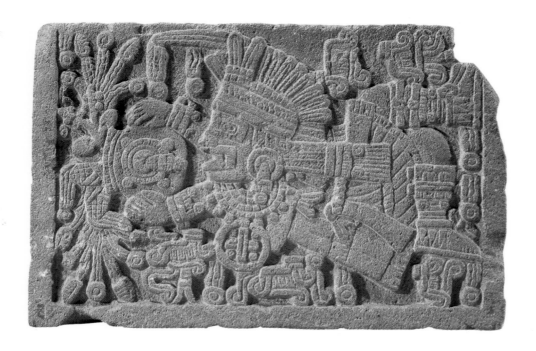

**▲ Funeral cask of Ahuitzotl**
The relief shows a tlaloc pouring water and maize from a stone vessel.

**◄ Eagle vessel, or quauhxicalli**
Such vessels were used to collect the blood and hold the hearts of sacrificial victims.

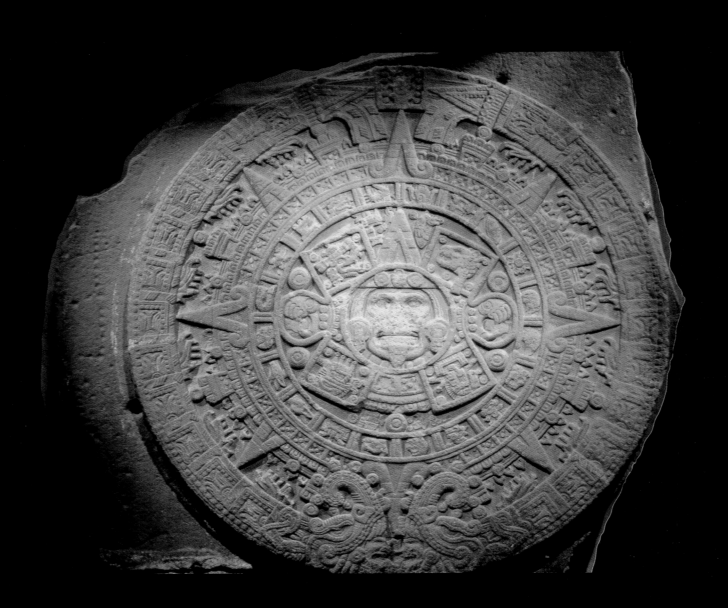

▲ **The Calendar Stone**
The design combines the sun and the earth monster.

glyphs and 16 images carved into it. The glyphs depict important dates in Aztec history. The back shows a surprisingly naturalistic scene, while the backrest is decorated with a highly stylized sun flanked by Montezuma II and the god Huitzilopochtli. Elsewhere the throne is decorated with eagles and jaguars and other emblems of war, along with skulls, the earth monster, and various symbols of death.

The **Bench Relief**, consisting of 52 panels, was found during the excavation of the main temple at Tenochtitlán. It shows a procession of warriors, with serpents along the cornices. Twenty-one of the panels are on display in the **Museo Nacional de Antropologia** in Mexico City. With the exception of the chacmool found in front of the temple of Tlalco in Tenochtitlán in 1979, the Bench Relief panels are the earliest examples of Aztec sculpture.

The **Stone of the Warriors**, discovered in 1897, also shows a procession of warriors. As on the Bench Relief, the warriors are depicted wearing three different types of headdress. They converge on a grass ball, into which sacrificial bones and thorns were placed.

In 1790, in Mexico City, when the foundations of the cathedral were being restored, the **Stone of Tizoc**, the **Calendar Stone**, and a statue of **Coatlicue** were unearthed. Tizoc ruled from 1481 to 1486 and his cylindrical stone is 3¼ feet (1 meter) high and nearly 10 feet (3 meters) in diameter. Its reliefs are not in the Toltec style seen on the Bench Relief and the Warrior Stone, but in the **Mixteca-Puebla** style found in Aztec manuscript paintings. The top is an ornate sun disk with eight rays. The side is fringed with a border of stars and the bottom shows the maw of the earth monster.

There is a depression in the center of the stone, which probably held an offering of blood. When a new ruler came to power, his first act was to go to war and bring back captives for sacrifice. Around the side of the stone are 15 pairs of figures, each showing a warrior holding a captive by the hair. Tizoc was not a successful ruler, however. In his first campaign he lost 300 men and brought back only 40 captives. He ruled briefly and died in mysterious circumstances, probably poisoned.

The Calendar Stone is well over 10 feet (3 meters) in diameter. The design combines the sun and the earth monster and depicts the creation of each new era and the destruction of the preceding one. The Aztecs believed that the first world had been populated by giants who were eaten by jaguars. The second world was blown away by hurricane

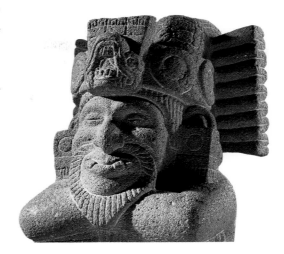

▲ **The god of fate**
The dragon face on his headdress signifies the stars.

► **Statue of Coatlicue**
The goddess wears a skirt of snakes.

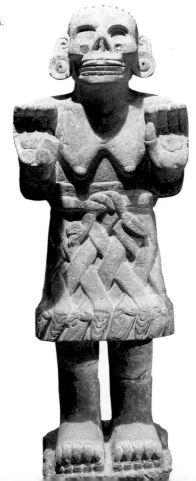

winds. The third world was destroyed by a fiery rain caused by the god Tlaloc. The fourth world was drowned by floods sent by the water goddess **Chalchiuhtlicue**. They believed that the fifth world, in which the Aztecs were living when Cortés came to their shores, would be destroyed by earthquakes.

The Calendar Stone, which dates to 1512, was the sacrificial stone of Montezuma II and was used in gladiatorial sacrifices. Montezuma ordered that it be taken out into the city on rollers, but a wooden bridge collapsed under its weight and it fell into the lake. Damaged, the stone was recovered and returned to the temple, but the incident was interpreted as another bad omen.

The **Dedication Stone** is a greenstone plaque carved to commemorate the completion of the Temple of Huitzilopochtli at Tenochtitlán in 1487. It shows the rulers Tizoc and Ahuitzotl dressed as priests, piercing their ears with a bone.

A similar slab of greenstone carries a relief showing the earth monster. Although it was carved about the same time as the Dedication Stone, the **Greenstone Earth Monster** uses the later **Mixtec-Puebla** style of the codices, rather than the more primitive style of the Bench Relief and the Stone of Tizoc.

A giant greenstone head–almost 3¼ feet (1 meter) high–of the goddess **Coyolxauhqui** was found in Mexico City, and, in 1978, one of the largest Aztec monuments ever discovered was unearthed near the cathedral. It was a stone oval nearly 13 feet (4 meters) long and it depicts the dismembered body of the naked Coyolxauhqui.

When the area around the **Coyolxauhqui Relief** was excavated, a number of stone statues, gold discs, and bells, skulls, animal bones, flint knives, obsidian, and other offerings were found. Among them were the greenstone relief of a goddess, over 3¼ feet (1 meter) in height. It has been identified as the pulque goddess **Mayahuel**. She was a fertility goddess associated with death. Why such a valuable piece should be buried with other everyday offerings is not known, but it is thought that she may have been an idol captured from an enemy temple and brought to Tenochtitlán before the construction of the Temple of Cihuacoatl.

**The Stone of Tizoc** ▶
Detail of the side of the stone showing warriors holding captives by the hair.

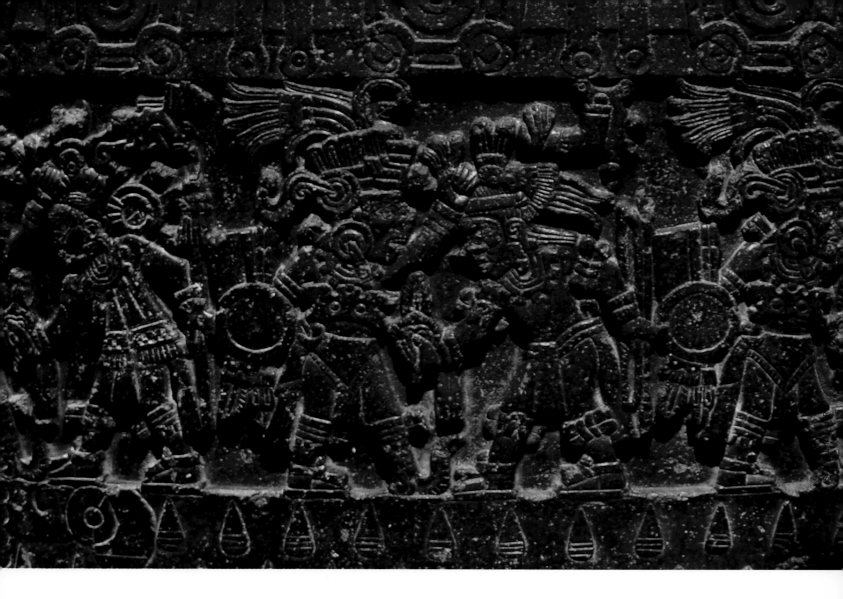

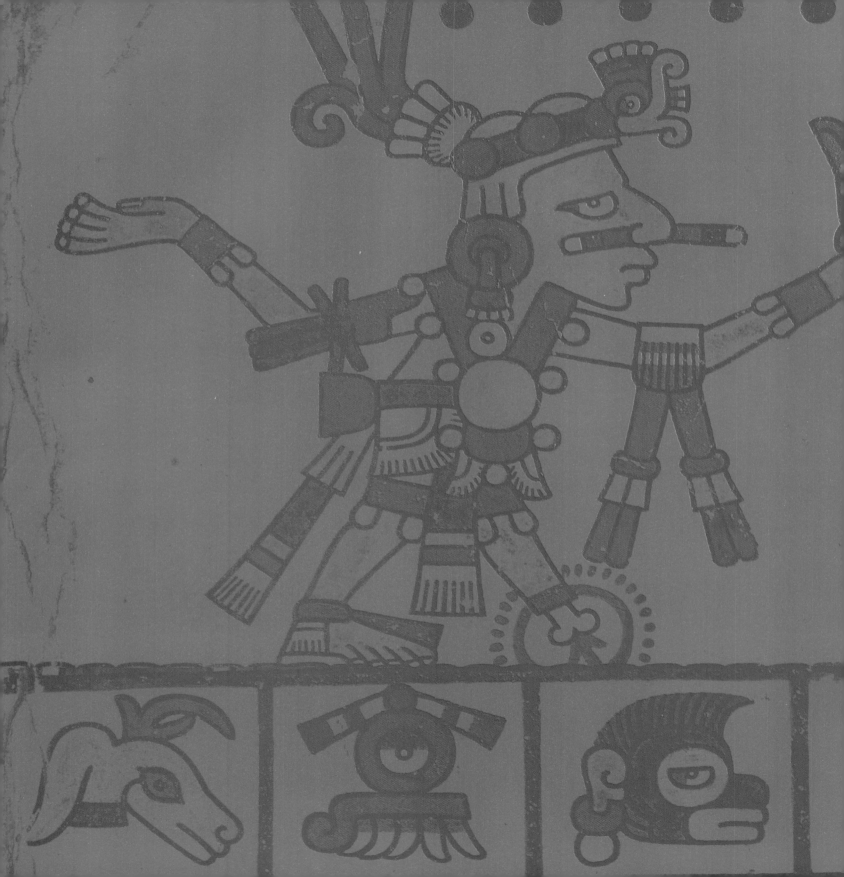

CODICES

5

The art of writing was well established in Mesoamerica centuries before the Aztecs came along. However, books were made from bark paper or deerskin, which decays rapidly in a humid climate.

The Aztecs produced many illuminated books, but the Spaniards, believing them to be heathen bibles, destroyed them. Only 14 pre-conquest works have survived. However, the Spaniards did instruct natives who had converted to Christianity to make copies of the old books—often perfect duplications—and to create new works chronicling their daily lives. This had not been part of the Aztec tradition.

Pre-Columbian books were painted on both sides of a long strip of material that was rolled up or given a corrugated fold. They combine pictures with pictographs and ideograms that had to be interpreted by priests and scholars.

The **Codex Borbonicus**, now in Paris, is the most colorful and elaborate of the known Aztec manuscripts. It was probably made after the conquest, but is a copy of a pre-conquest work. The manuscript is folded and measures about 15½ inches (40 centimeters) square. The first and last two pages are missing.

The codex comprises three parts. The first is a **tonalamatl** or "book of days," used by the priests for prophesy. The second chronicles the 52-year cycle that makes up the Aztec "century." The third records the schedule of religious festivals.

► **The Codex Borbonicus**
An illustration depicting a sacrificial celebration dedicated to the gods.

BORBON

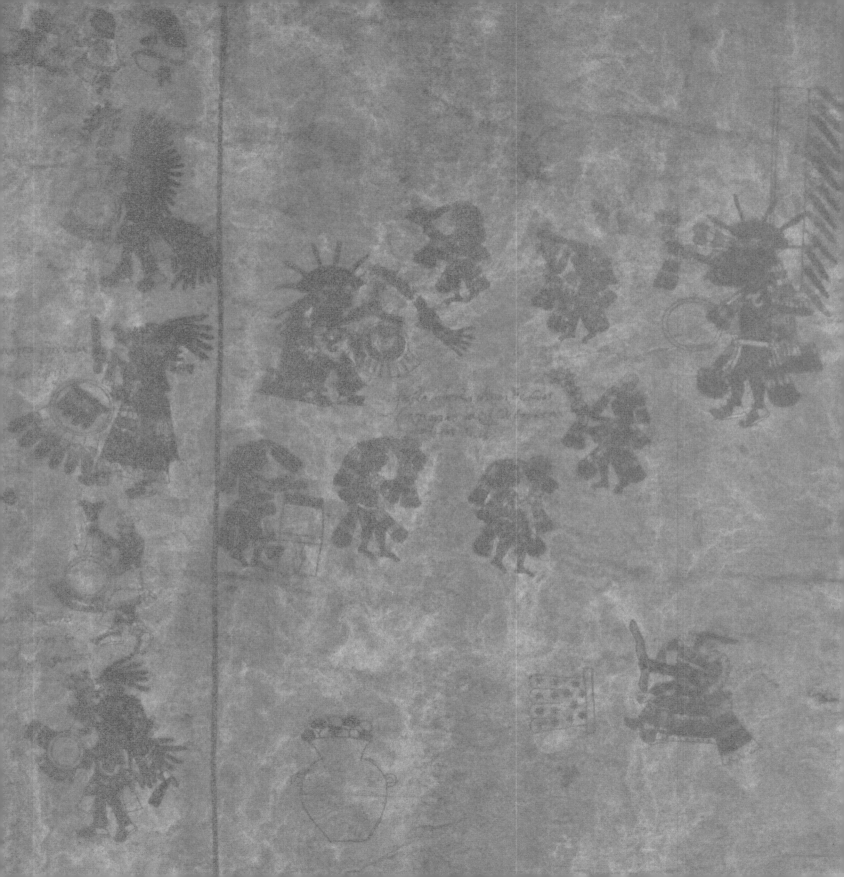

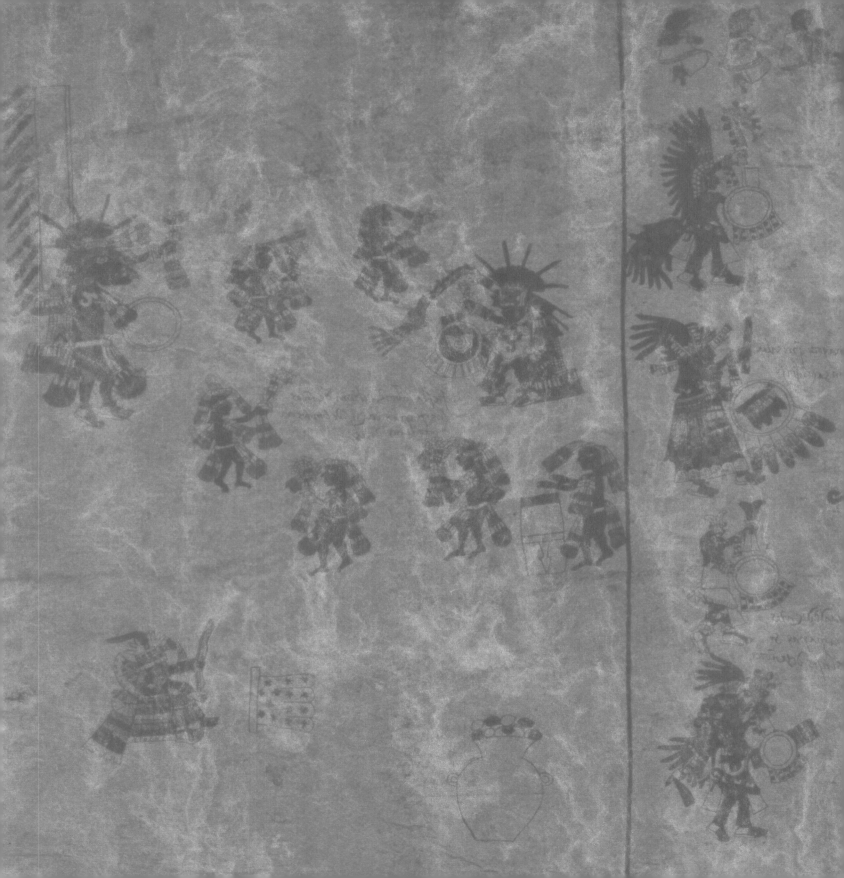

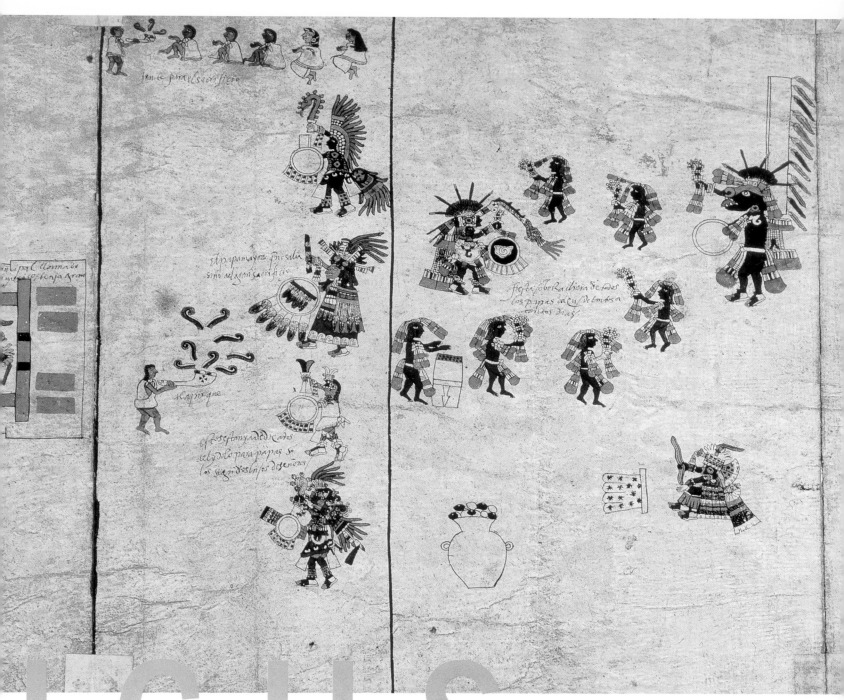

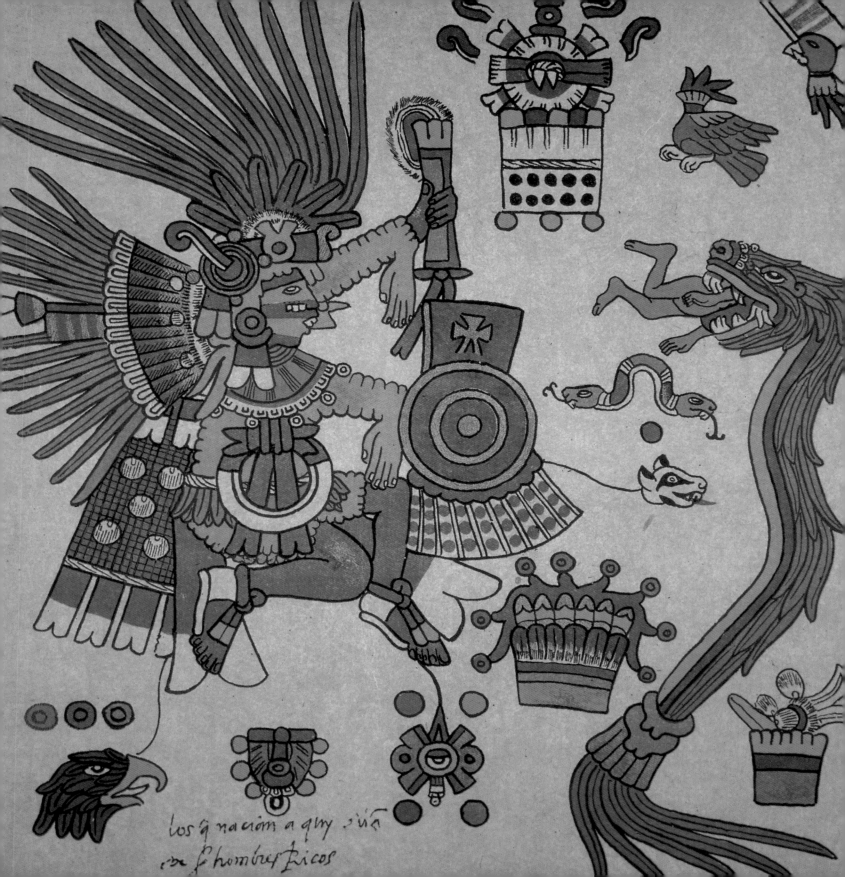

los q̃ nacion a qui siua
e ̃ hombres Ricos

It divides the Aztecs' 260-day year into 20 weeks consisting of 13 days each. Each day is ruled over by a **Lord of the Day**, accompanied by a bird and an insect. The nights are ruled over by nine **Lords of the Night**, who sometimes double up as Lords of the Day and represent the nine levels of the underworld.

The book was consulted when setting a date for a wedding, planning a journey, declaring war, or deciding the fate of a criminal. When a child was born, its name and future path would be gleaned from the book. It was also used in secret rituals.

The major illustrations in the Codex Borbonicus show gods and goddesses at work, including **Xochiquetzal** and **Tlazolteotl**, the goddesses of sexual love and adultery, respectively. **Quetzalcoatl** and **Tezcatlipoca** are also featured.

The **Audin Tonalamatl** is another copy of a pre-Columbian work, possibly an inferior copy of the book upon which the Codex Borbonicus was based. It is less colorful than the Borbonicus manuscript, poorly rendered, and less complete. It features a number of gods as Lords of the Weeks: the god of Venus **Tlahuizcalpantecuhtl**, the god of fire **Xiuhtecuhtli**, **Tepeyollotl**, and **Tezecatli** as a jaguar. Both manuscripts also feature ball courts, the board game patolli, and, of course, severed heads.

The **Codex Boturini** records the migration of the Mexica before the foundation of Tenochtitlán. It is typical of the type of manuscript produced under the Spaniards, but again it may be a copy of an earlier work. The illustrated figures are simplified and outlined in black. Dates are indicated by red lines and little black footprints show the direction of the migration.

◄ **Two of the gods in the Codex Borbonicus**
Xipe Totec is depicted in a flayed skin and Quetzalcoatl as the feathered serpent.

CODICES

The **Mapa Quinatzin** came from Texcoco, which was said to have boasted the greatest artists of the Aztec empire. Only three sheets of what was probably a long roll remain. One shows the origins of the Texcocan dynasty. Another depicts the exile of the Texcocan king Nezahualcoyotl in Tenochtitlán. And the third shows the new laws enacted by Nezahualcoyotl when he regained the Texcocan throne. These include the death penalty for adultery and for squandering the family inheritance.

The **Codex Mendoza** was commissioned by Antonio de Mendoza, the viceroy of Mexico. It shows the history of the Mexica and scenes of daily life. Part of it, the **Matrícula de Tributos**, is a copy of a book recording the goods delivered as tribute to Tenochtitlán by conquered territories. Such books were used by the Spanish to set up a tribute system of their own.

**The Codex Fejervary-Mayer ▶**
The frontispiece of the manuscript depicts the creation myth inside a Maltese cross bearing 260 dots, one for each day of the Aztec calendar year.

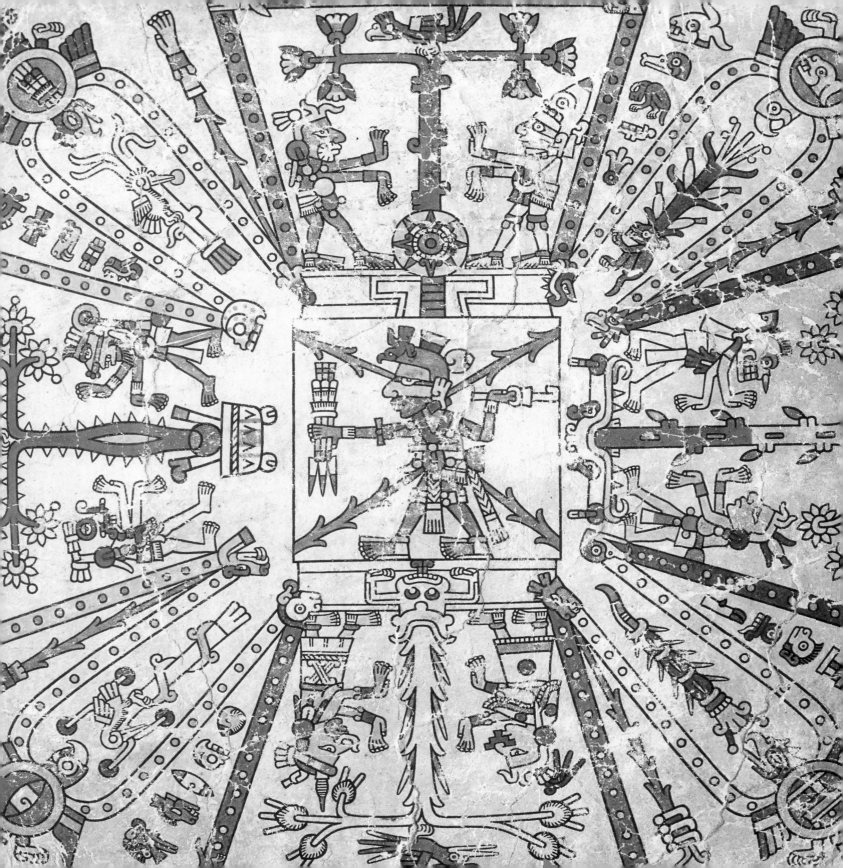

# JEWELRY

6

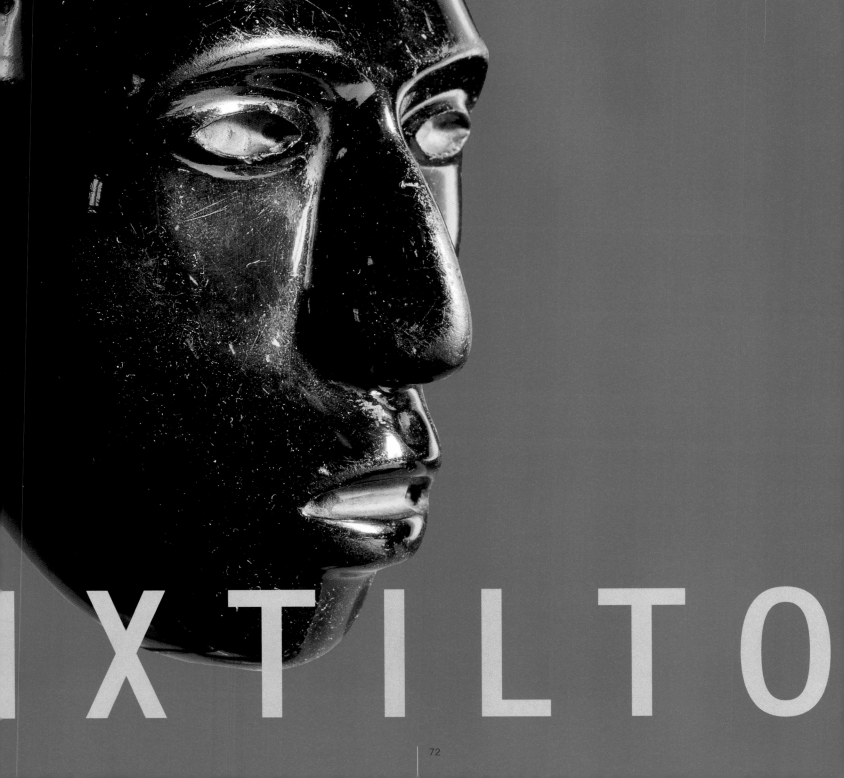

IXTILTO

Although the Aztecs had copper and bronze tools, they were essentially **Neolithic**. **Flint** was used to make knives and **obsidian**, volcanic glass, was used to make the blades of swords. Obsidian was also carved to make small containers and ornaments. The Aztecs were skilled at cutting and polishing obsidian and made mirror and ear spools as thin and delicate as if they were machine-made.

**Onyx** was also used to make small vessel and figurines. The stone itself came from the Gulf Coast and some onyx items were probably imported ready-carved.

**Greenstones**—serpentine, jade, and diorite—were particularly prized by the Aztecs and were often buried in temple floors as an offering to the gods. **Turquoise** and the iridescent green feathers of the **quetzal** were also incorporated. **Gold**, although widely used, was not highly prized and was described dismissively as teocuitlatl—the excrement of the gods.

Greenstone came, as tribute, from **Guerrero** and was worked at **Chalco** and **Xochimilco.** It was cut using flint and copper tools, then polished using sand and bamboo.

Jade was used to make necklaces, masks, ritual objects, and larger sculptures. The masks were not worn. They were used as ornaments only as they had no holes for the eyes.

**Quauhxicalli**, or eagle vessels, were also carved from greenstone. Three of those surviving have a relief showing the sun in the guise of an eagle in the bottom. Under the base is a carving of the earth monster with its mouth open, surrounded by skulls.

◄ **Obsidian mask**
Ixtilton, the god who brought darkness and peaceful sleep to children.

The **Hamburg Box** is a rectangular jade box made late in the Aztec period. Five figures and seven glyphs are carved on its inner and outer surfaces. Montezuma II is shown drawing blood from his ear and Quetzalcoatl is also depicted, dead. Many of the images echo those on the Temple Stone.

In Stuttgart, there is a carved greenstone statuette showing a skeletal male god. This is Quetzalcoatl, depicted not as the usual benign god but as a god of destruction. He has the eagle and sun disk on his back, but the glyphs on the figure do not refer to the dates of great triumphs in the Aztec calendar—they are probably the dates of great disasters.

A greenstone pulque beaker in Vienna, carved in the same sophisticated style, shows similar scenes of death and destruction. These two items are thought to have been carved after 1519, when Cortés, whom Montezuma associated with the prophesied return of Quetzalcoatl, began to reveal his destructive intent.

**Wood** was carved to make shields, drums, masks, and spear-throwers. Approximately 20 elaborately carved wooden drums have been found. Large wooden sculptures were also made and covered with gold foil, feathers, and mosaics of turquoise. Less than ten survive.

**Turquoise mosaics** developed early in Mesoamerican culture. The stone came as tribute from the southern cities that the Aztecs had annexed. The technique of making mosaics had been perfected by the Mixtec and other descendants of the Toltecs whom the Aztecs had conquered. Being blue, turquoise was used particularly on statuettes of the rain god **Tlaloc** and also for **Chalchiuhtlicue**, the goddess of rivers and lakes.

▶ **Gold and turquoise breastplate**
The breastplate is fashioned as a shield pierced by four arrows.

▼ **Turquoise and shell mosaic**
The handle of a sacrificial knife in the form of a kneeling deity.

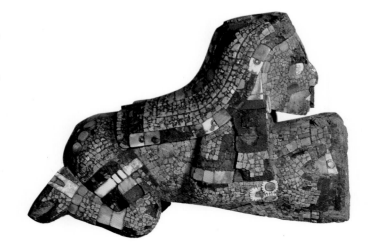

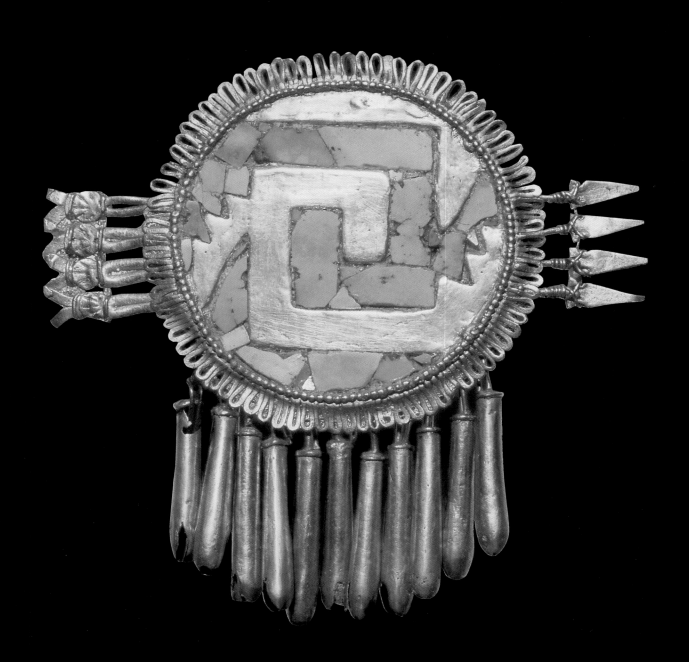

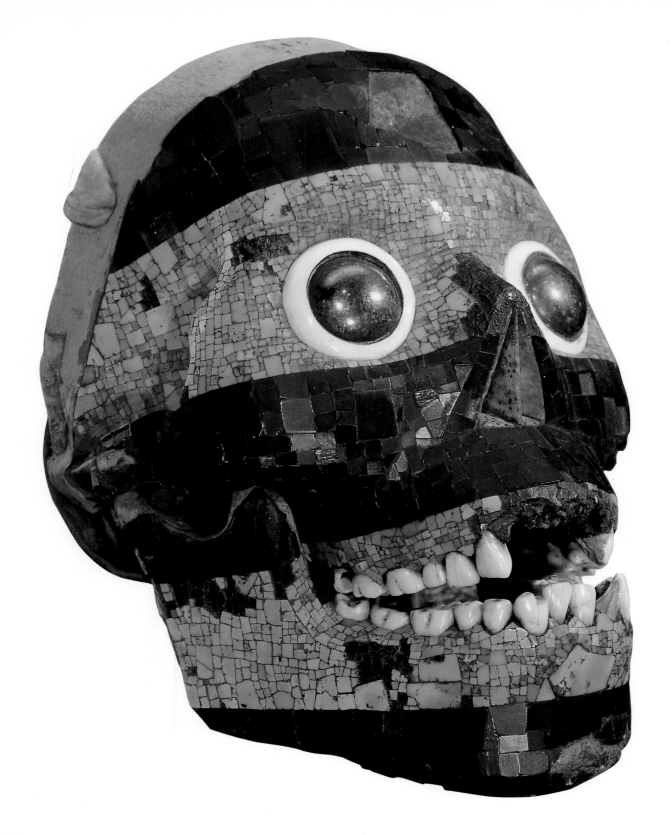

Some large idols are completely covered in turquoise. It was also used to cover ritual containers, sacrificial knives, masks, staffs, head-dresses and ceremonial helmets, shields, standards, and weapons.

The **gold adornments** worn by Aztec nobles were made by Mixtec craftsmen working in Tenochtitlán. They had developed the tradition of metalworking in their own homeland, Oaxaca, around the 10th century A.D. The discovery of a Mixtec tomb in **Monte Albán**, filled with rings, pendants, earrings, and necklaces, revealed their extraordinary craftsmanship.

The Mixtecs themselves had learned their skills from an older metal-working tradition that started in 2000 B.C. in the Andes and slowly spread northward. By A.D. 900, **copper** was being smelted along the Pacific coast of Mexico. It was used to make needles, tweezers, axes, figurines, and bells for dance costumes. **Bronze** was also produced.

Gold was panned and collected as nuggets from riverbeds. It was smelted in charcoal furnaces and given extra draft by men blowing through tubes. Items were cast by the lost-wax method. Mixtecs adopted methods for **gilding** copper from South America. They also mixed copper and gold to produce an alloy called **tumbaga**.

The Mixtec craftsmen of Tenochtitlán combined filigree and cast gold with jade, turquoise, and crystals. Sadly, most of this work was destroyed by the Spanish, who melted down the gold to ship back to Spain. However, the few pieces that survive show a distinctive style and craftsmanship that equals anything found in pre-Columbian America.

JEWELRY

◄ **Mask of Tezcatlipoca, the god of chance**
Turquoise mosaic, obsidian, and gold pyrites set over a human skull.

▼ **Teotihuacán death mask**
The eyes would once have been filled and the mouthpiece indicates high rank.

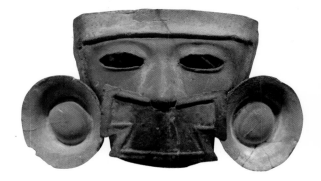

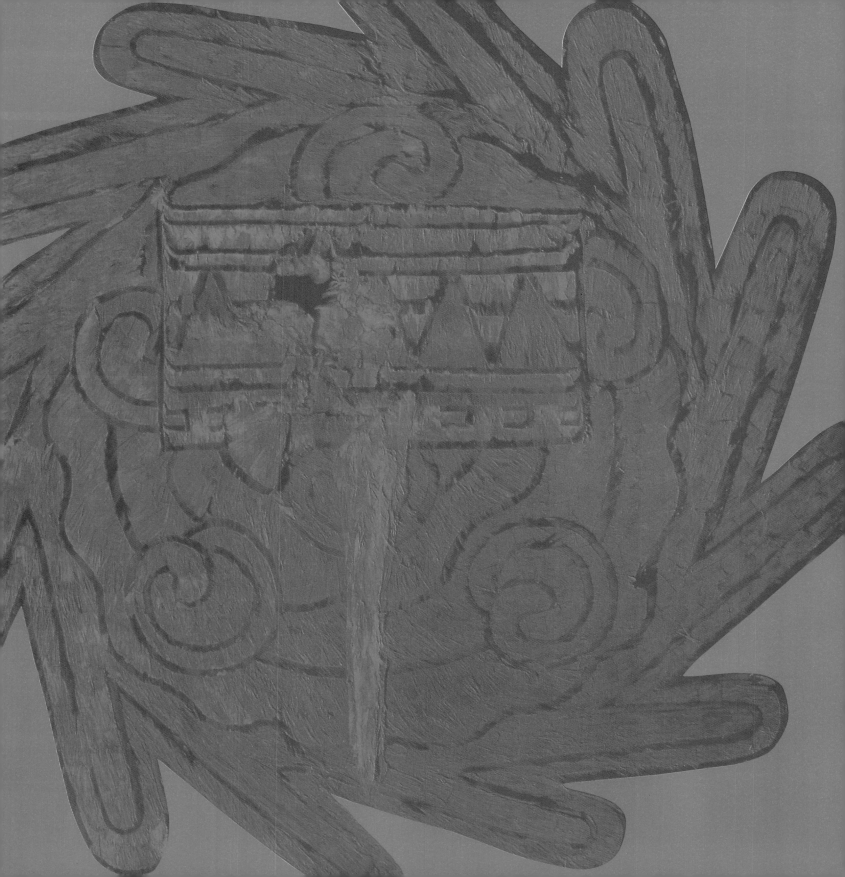

# TEXTILES AND WEAVING

7

To the Aztecs, **featherwork** was as valuable as turquoise, green-stone, silver, and gold. While ordinary foot soldiers wore animal pelts, the aristocrats and military commanders wore elaborate outfits made from feathers. Although featherwork was costly and time-consuming to produce, it had little value to the Spaniards. However, shiploads of feathered costumes were sent back to Europe as curios. Unfortunately, the institutions and individuals who received them had no way to preserve them and only eight survive, five of which are shields. In Mexico, the craft of featherworking continued into the 19th century.

The feathers of the **quetzal** were the most precious and sought after, but the plumage of other colorful tropical birds–parrots, hummingbirds, the scarlet macaw, the blue cotinga, and the red spoonbill–was also used. Feathers were sewn onto clothes in overlapping colors, with glued-on insignia and shields, sometimes with gold added.

Feathered costumes denoted rank and were awarded according to the number of captives–that is, sacrificial victims – the warrior had taken. There were about 20 ranks in all. The basic **ceremonial costume** comprised a feathered tunic and skirt, along with a head-dress and standard on the back. The emperor in Tenochtitlán and the king of Texcoco wore the symbolic skin of the flayed god **Xipe Totec**, rendered in feathers, as their uniform and carried either a gilded or blue drum.

These costumes were extremely cumbersome and, in consequence, war became a highly ritualized affair. They certainly offered no protection from Spanish weapons and the restricted movement they allowed gave the Aztecs no chance to fight back against Cortés's men.

One of the shields that survived, now in Mexico City, was probably used for ceremonial rather than combat purposes. It shows the face of **Tlaloc** emerging from a pool of water. Made from feathers and gold, it is some 9½ inches (24 centimeters) in diameter. Two shields in Stuttgart feature geometric designs and originally belonged to high-ranking military commanders.

A shield in Vienna shows the water monster **Ahuitzotl**; it was found packed away with a headdress, mantle, and fan. The head-dress is over 45 inches (115 centimeters) high. It is hung with lines of gold disks and combines nearly 500 green quetzal and blue cotinga feathers. There were once more feathers, but some were removed by the **Archduke of Bavaria** to decorate his own hat and his horse.

**Featherworkers ▶**
Feathers were used to make ceremonial costumes, shields, fans, and headdresses.

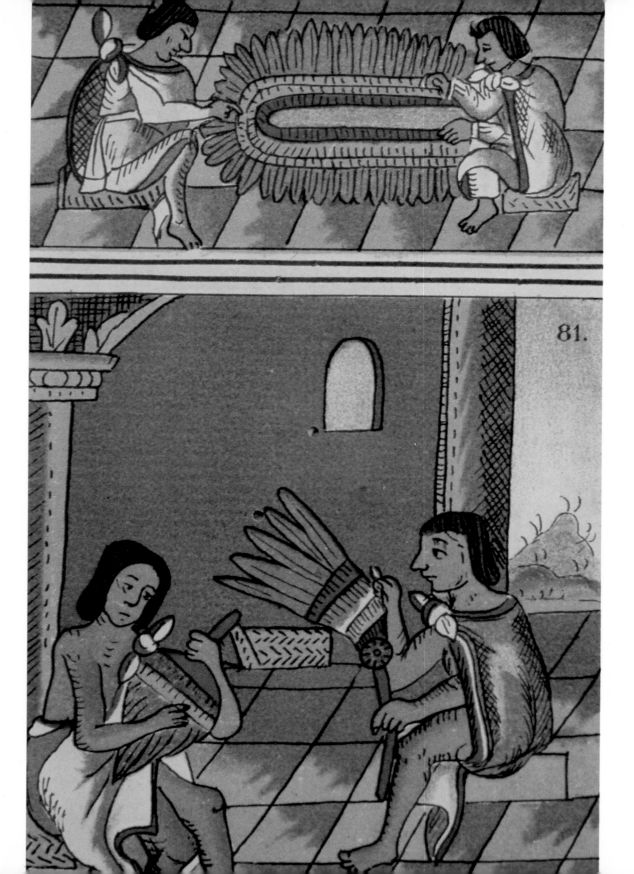

81.

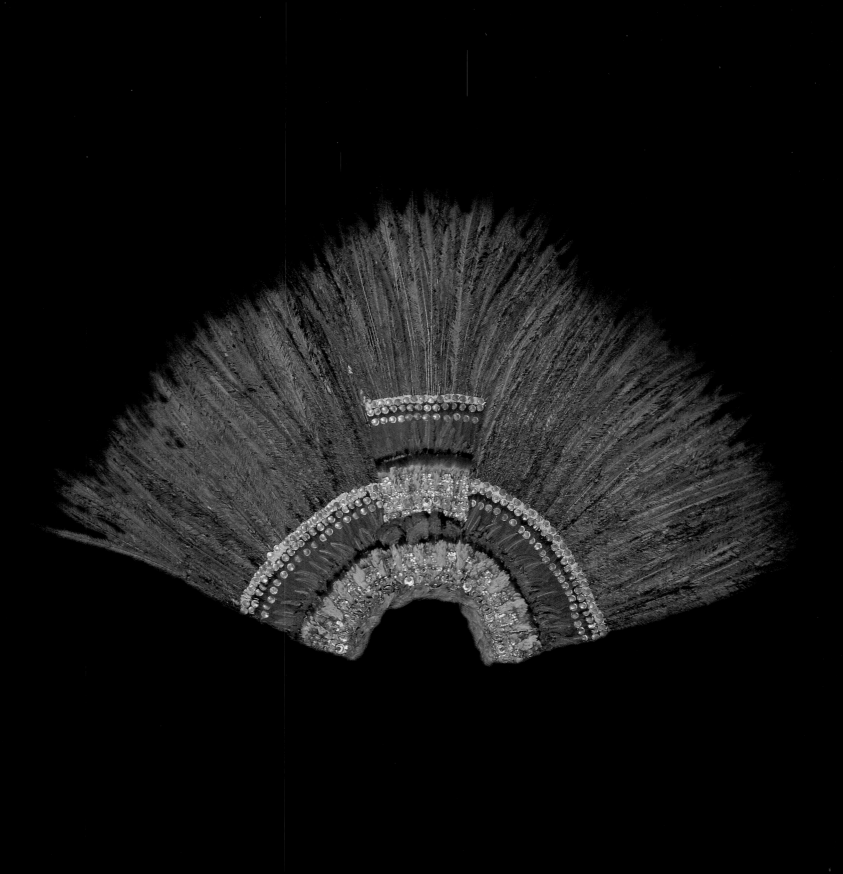

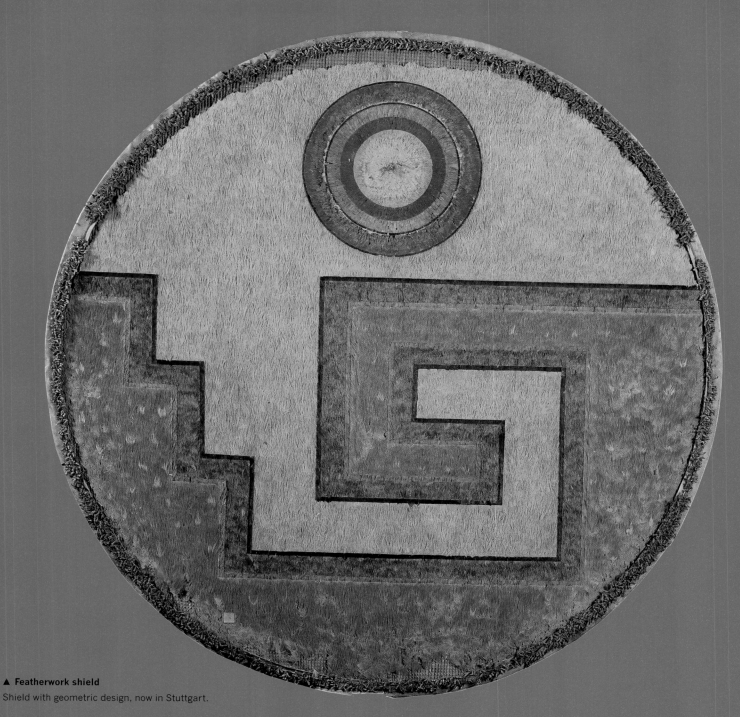

▲ **Featherwork shield**
Shield with geometric design, now in Stuttgart.

◀ **"Montezuma's crown"**
Featherwork headdress decorated with gold disks.

Although popularly known as **"Montezuma's crown,"** the headdress is probably not Montezuma's at all–the Codex Mendoza states that the king wore a turquoise crown.

The mantel is made of green feathers, with black, blue, and red around the borders. These sit on a black netting. Unfortunately, it is in a bad state of repair. The fan is magnificently preserved, though. It is constructed on a bamboo frame and is circular in design. In the center, there is a bee on one side and a flower on the other. Around that, there is a rainbow of colored feathers, ringed by blue cotinga plumage.

In everyday life, **woven textiles** were worn but, due to the humid climate of southern Mexico, little has survived. According to Spanish accounts and Aztec records, each region in the empire had its own distinctive designs that were painted, dyed, woven, or embroidered onto basic garments.

Men wore loincloths and capes. Women wore skirts and, if they were upper class, huipiles or mantels. Peasant women went bare-breasted. Clothes were made of maguey or henequen, both agave fibers. These materials are coarse and rigid, and considerable skill was needed to weave them into a delicate, flexible cloth. Cotton was also cultivated, but was probably only used by the upper classes. People at all levels of society wore the same basic garments. Only the quality of the material, the fineness of the weave, and the decoration distinguished the wearer's social status.

Garments were not tailored, but were often embroidered with geometric designs and pictures of local flora and fauna. Vegetable dyes were used, along with those from mineral sources, such as yellow ochre and blue clay. The color violet was obtained from the secretions of coastal mollusks, and red was obtained from cochineal insects raised in cactus groves.

The reed beds of the highland lakes provided the raw materials for **basket making** and **mat weaving**. Palm leaves, cane slats, fibers from cacti, and the broad leaves of the maguey agave were also used. Baskets were employed for carrying and storing grain and other foodstuffs. Fine baskets with a tight weave were used for carrying personal items and as household objects. Large rectangular baskets with lids were used as storage chests for clothes. The Aztecs also wove reed seats and mats or petlatls. **Furniture** was limited to low tables, stools, and litters, so durable mats like Japanese tatami were vital. These are being produced in the Toluca Valley to this day.

◄ **Featherwork shield featuring the water monster Ahuitzotl**
The shield, now in Vienna, depicts the creature with a sacrificial knife in his jaws.

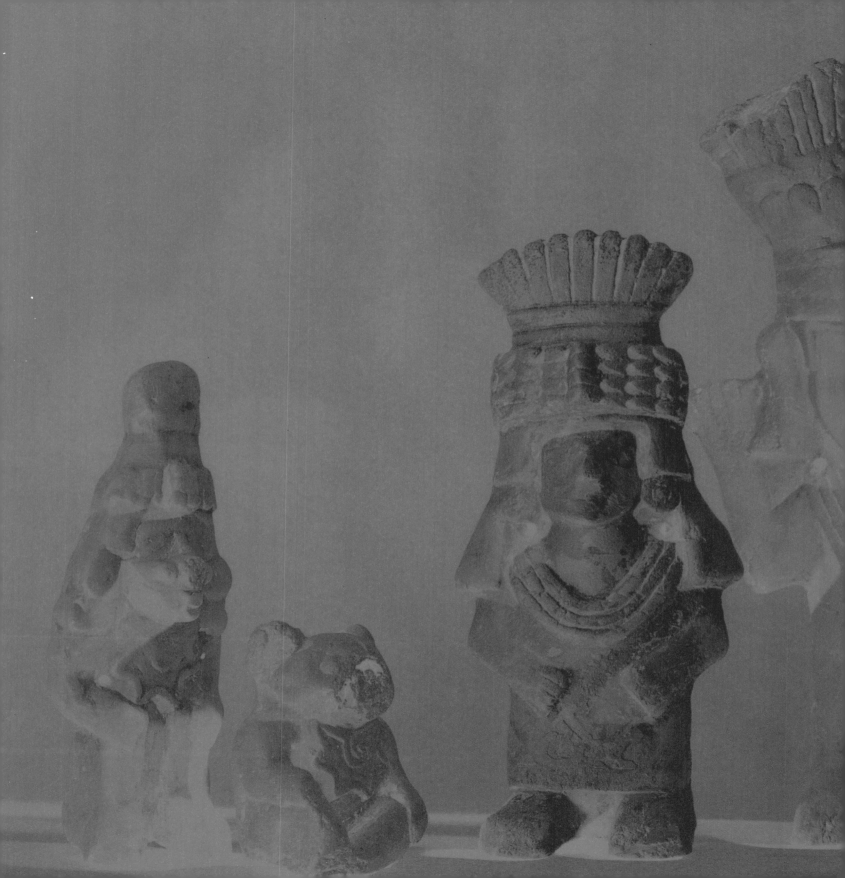

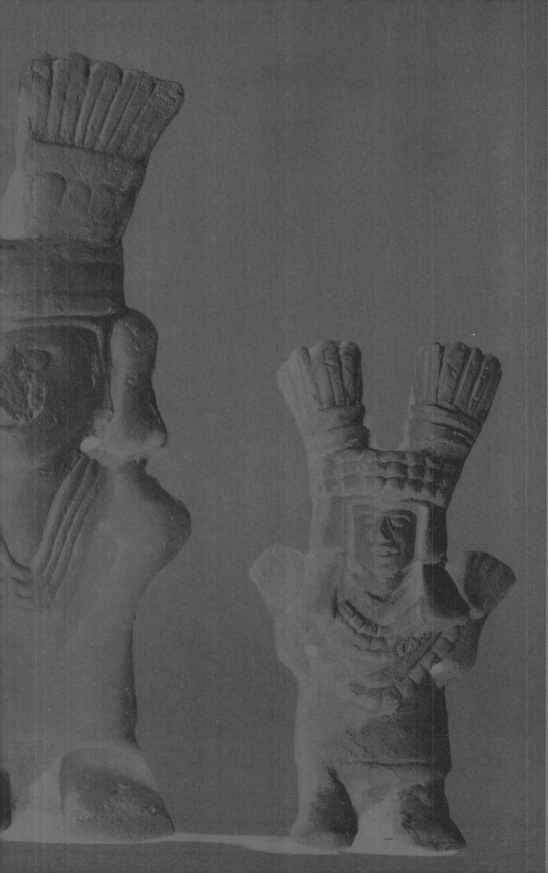

# POTTERY
## AND
# CERAMICS

# 8

XIPE TO

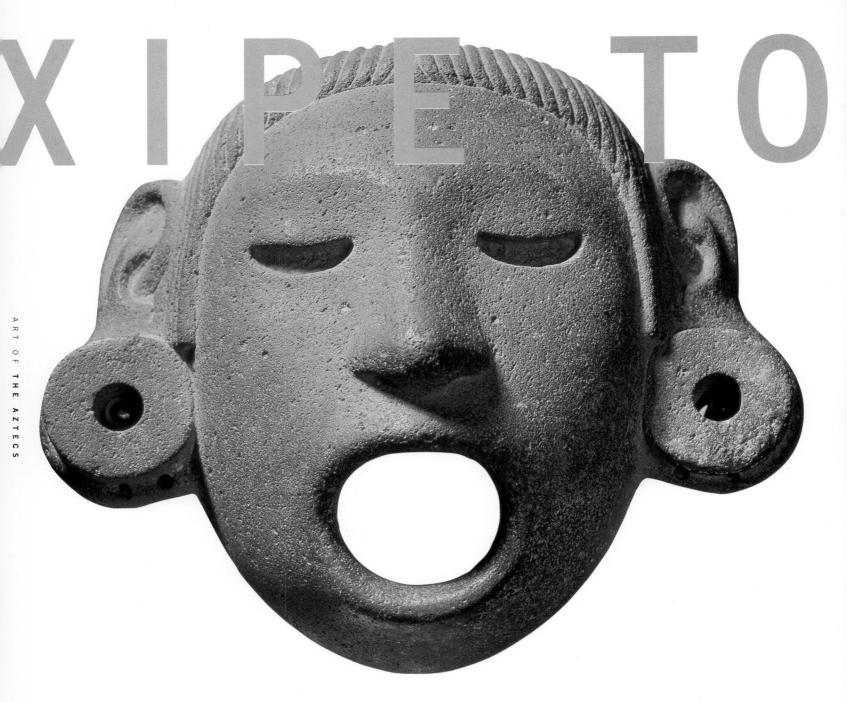

▲ **Stone mask of Xipe Totec**
The Aztecs generally preferred to make sculptural pieces in stone rather than clay.

# TEC

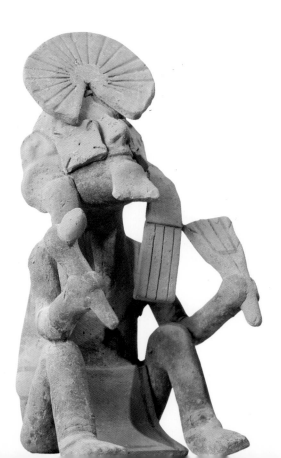

**Terra-cotta** figures of the gods were mass-produced in Mesoamerica long before the Aztecs arrived. The Aztecs themselves were much more interested in stonework than terra cotta. However, some large terracotta pieces from the Aztec era have survived.

One early example is a 55-inch (140-centimeter) tall statue of **Xipe Totec**, the flayed god. The figure appears to be wearing a feathered garment, like the one the emperor would wear when going to war. An unusual aspect of this figure is the genitals, which are not usually depicted in Aztec art. In this case, it is clear that the phallus is erect under the figure's costume. This highly sexual representation is more usually associated with peoples to the east and the south of the region than with the Aztecs.

A large terra-cotta plaque, some 12 inches (30 centimeters) square, was found at **Culhuacan**. It shows the head of a god–possibly the fertility god **Xochipilli**–with an object that looks like a butterfly in his mouth. Plaques like this were probably set into the walls of shrines and temples, alongside stone reliefs.

Large numbers of smaller pieces have also been found. They usually depict animals or naked or simply dressed men and women, probably figures of the household deity. In Aztec times, even the humblest home had a shrine. At every **New Fire Ceremony**, which occurred at the end of each 52-year Aztec century, the old figurines were replaced with new ones.

The most common figurine is of a **woman with babe in arms**. This is thought to be a symbol of fertility. The figurines are hollow and some have same balls of clay inside, so that they act as rattles. They are made from a reddish clay, although some show signs of a coat of white paint. They also have a solid base or feet, so that the figurine can stand. Some of the female figures do not wear the headdresses associated with the various female deities; instead, the headdress is bunched into two horn-shaped projections, in the common practice of everyday Aztec women. These figurines, therefore, might simply be idealized depictions of ordinary women. Many of them are bare-breasted.

While many of these female figures do not resemble the stone sculptures found in temples, the rarer male figures do. They also show more variety. Most common are figures of the wind god **Ehecatl**, the rain god **Tlaloc,** and the god of dance, pleasure, and sexuality **Macuilxochihl**, who wears a distinctive crested headdress.

Ritual music and dance seem to be a major theme, as are the martial arts, with the flayed god **Xipe Totec** prominent once again. The gods are also associated with various diseases, so the purpose of these figurines may have been to protect the household from illness.

Other terra-cotta ornaments include **model temples**, often with a deity incorporated into the design. These come in a huge variety styles and are thought to have been sold as souvenirs to visitors to the temple portrayed.

The Aztecs made functional objects out of clay, too—**dishes**, **stamps,** and **incense burners** among others. Excavations at the main temple in Tenochtitlán have revealed incense burners 3¼ feet (1 meter) tall, with large figures carved into the side in high relief.

One incense burner unearthed at **Tlatelolco** is 25 inches (64 centimeters) tall and depicts the maize deity. Another, 38 inches (97 centimeters) tall, has a tripod base and an abstract arrangement of spikes adorning the sides. A large number of hand-held incense burners shaped like spoons were found in the **Escalerillas Street excavations**, which unearthed the corner of the main temple in Tenochtitlán in 1902.

The Aztecs thought that **Mixtec pottery** was finer than their own and imported it from **Cholula**. Mixtec pottery was colorful and ornate, decorated with both abstract patterns, such as stepped frets, and elaborate narrative scenes. **Aztec pottery** usually used one color only, generally a black pattern on an orange or red background, although white was sometimes added too. Redware is associated with Texcoco and is highly burnished. Elsewhere a white slip was applied before the black decoration was added.

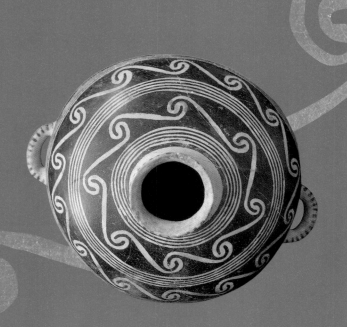

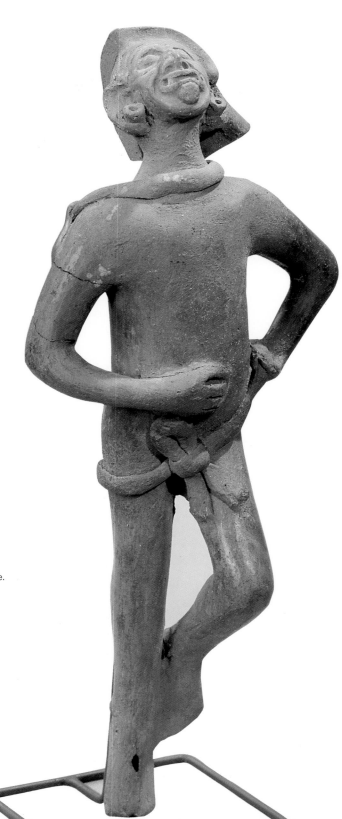

► **Male figurine**
The statuette depicts a man singing and dancing at a festival, a popular Aztec theme.

◄ **Ceramic vessel**
Spirals and parallel lines are typical Aztec decorative motifs.

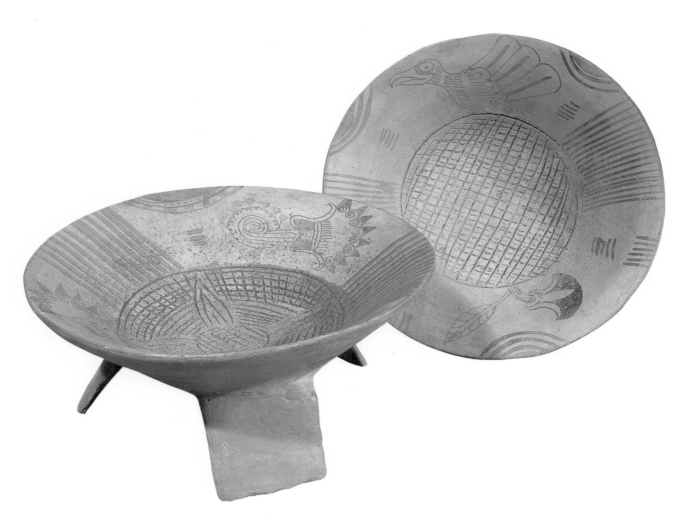

▲ **Hand-coiled domestic pottery**
The crosshatched lines in the base of the bowls were used for grating chilli peppers.

**Pottery designs** were generally abstract–stepped frets, spirals, and wavy lines–and Toltec in origin, but skulls and crossed bones also appear as decoration. Bowls and plates often have tripod bases. The sides of some small bowls have a rough crosshatching for grating chilli peppers; others have separate compartments at different levels.

Pottery was an important part of the Aztec economy. The largest section of the market at Tlatelolco was set aside for pottery sellers. The potter's wheel was not used in the Americas until the arrival of the Europeans, and plates and bowls were handmade by coiling strips of clay or assembling molded sections. The Aztecs followed the ancient tradition of low-fired earthenware. They had not developed the use of glazes, porcelain, or high-fired earthenware.

Early Aztec pottery was thick and poorly fired, but as the Aztec empire reached its zenith, there was a vast improvement in quality. **Decoration** became **ornate** with the sophisticated symmetries and motifs seen in the codices.

By the 15th century, Aztec pottery had become fine and thin-walled. Elegantly proportioned, cream-colored or red-slipped ware was decorated with fine geometric patterns. Toward the end of the Aztec civilization, patterns became more rounded and naturalistic, depicting flowers, fish, and other animals. The most highly prized items, such as those found in **Montezuma's palace**, were made in Cholula. Polychrome earthenware painted with colored mineral slips and burnished before firing was made there.

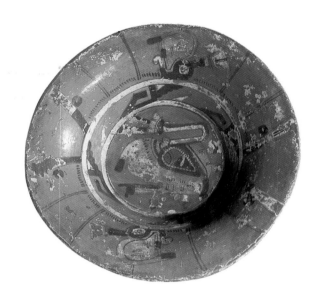

▲ **Ceremonial plate**
A jaguar is in the center, surrounded by the symbol of fire.

◀ **Clay pipe**
An eagle head, a symbol of the sun god, forms the bowl of the pipe.

Aztec potters also made special **ceremonial ware** for use in temples. A pair of blue Tlaloc vases has been found painted with frescos reminiscent of the frescoed pottery of Teotihuacán. A pair of cylindrical vessels was also discovered that had had Aztec gods carved into their surfaces while the clay was still wet, a technique used by the Maya. Incense burners painted in brilliant colors also borrow from the Maya.

While the other Aztec arts died out with the Spanish invasion, ceramic work did not. In colonial times, molded figures of Spanish soldiers and friars became popular. Spanish themes were incorporated into pottery designs, but **distinctly Aztec designs** also continued to be produced into the 17th century—because the depiction of Aztec symbols such as eagles, jaguars, and monkeys were naturalistic, the Spanish did not consider them idolatrous and so allowed their production. The skeletal heads that the Spanish would have destroyed on public monuments appeared quite safely on the side of pulque beakers.

Ceremonial plates continued to be produced. One, in the **Museo Nacional de Antropología** in Mexico City, is an undulating disk mounted on three disk-shaped legs showing an eagle and a jaguar intertwined, urging unity among Aztec warriors; because the animals were naturalistically rendered, the Spanish did not see its significance.

▼ **Household deities**
Even the humblest Aztec household had its own shrine.

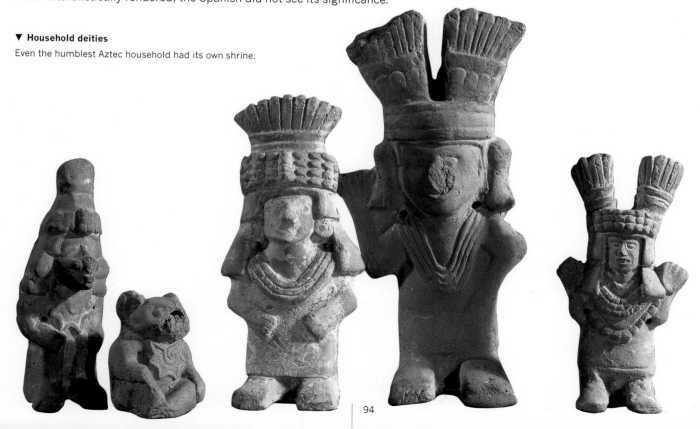

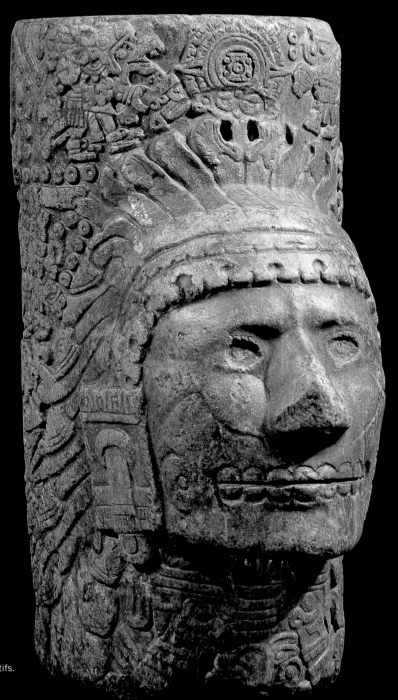

▶ **Pulque drinking vessel**
Intricately decorated with Aztec motifs.

◄ **Vessel in the form of a hare**
Probably used to hold cocoa, often drunk through gold straws.

PICTURE ACKNOWLEDGEMENTS
**AKG**, London 24, 29, 32, 38, 38 Background, 51 right, 54, 64 tracing, 65, 95/
Biblioteca Nacional, Mexico Endpapers.
**Bridgeman Art Library**/Biblioteca Nazionale Centrale, Florence 6-7/British Museum,
London 88/Museum of Mankind, London 9/Private Collection frontispiece,
frontispiece tracing.
**Corbis UK Ltd** 8, 23, 25, 28, 31, 42-43, 45, 50, 56, 59 Bottom, 77, 90/Mexico City
Museum, Mexico City 13.
**E.T. Archive** 12, 66, 67, 81/Museum of Mankind 53/The National Museum of
Anthropology, Mexico 46.
**N.J. Saunders** 30
**Robert Harding Picture Library** 2, 4-5, 20-21, 33, 34, 36-37, 40-41, 58, 61, 82, 83.
**Werner Forman Archive** 14-15, 16 tracing, 18-19, 26-27, 86-87, 94/British Museum,
London 10, 48, 51 left, 56 Background, 57, 76, 93 Top/Dallas Museum of Art, USA
17 Top/Hamburg Museum fur Volkerkunde, Germany 49/Liverpool Museum,
Liverpool 62-63, 68 Bottom, 69, 97/Merrin Collection 55/Museum fur Volkerkunde,
Basel 47, 48 tracing, 59 Top, 72, 73/Museum fur Volkerkunde, Basel, Switzerland 39
/Museum fur Volkerkunde, Berlin 89, 91, 92/Museum fur Volkerkunde, Vienna 84
/National Museum of Anthropolgy, Mexico City 79/National Museum of Anthropol-
ogy, Mexico 16, 70-71/National Museum of Anthropology, Mexico City 11, 19, 35,
75, 78, 80 tracing, 96/Pigorini Museum of Prehistory and Ethnography, Rome 74
/Private Collection, New York 17 Bottom, 32 tracing/Smithsonian Institution,
Washington 93 Bottom.

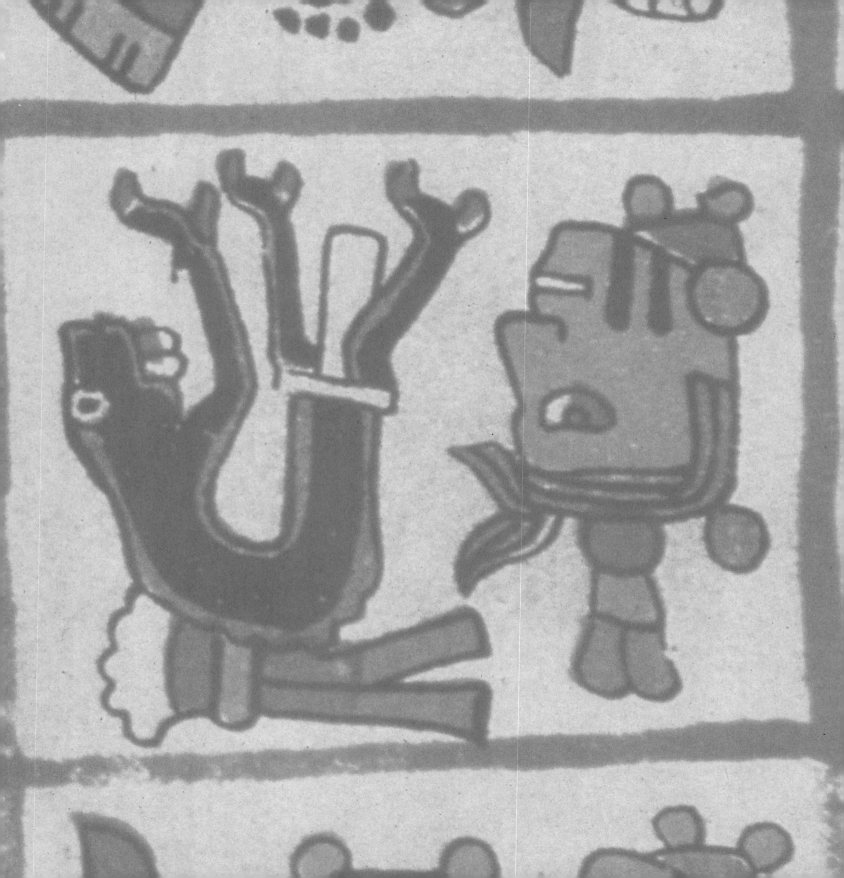

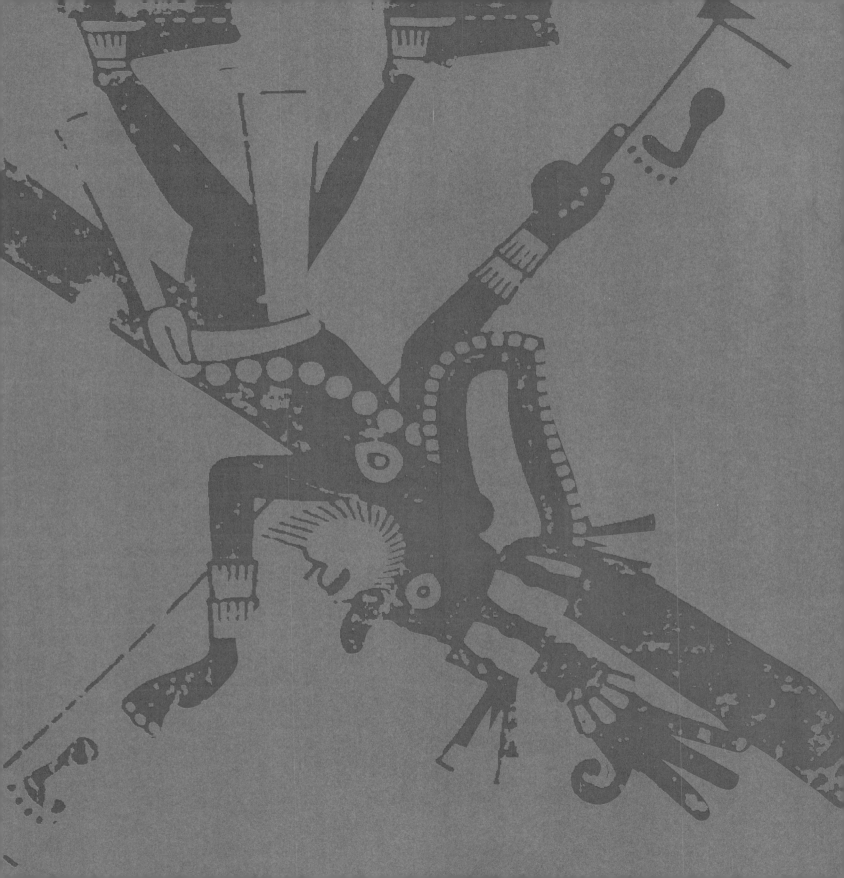